Watercolor Basics: Painting Snow and Water

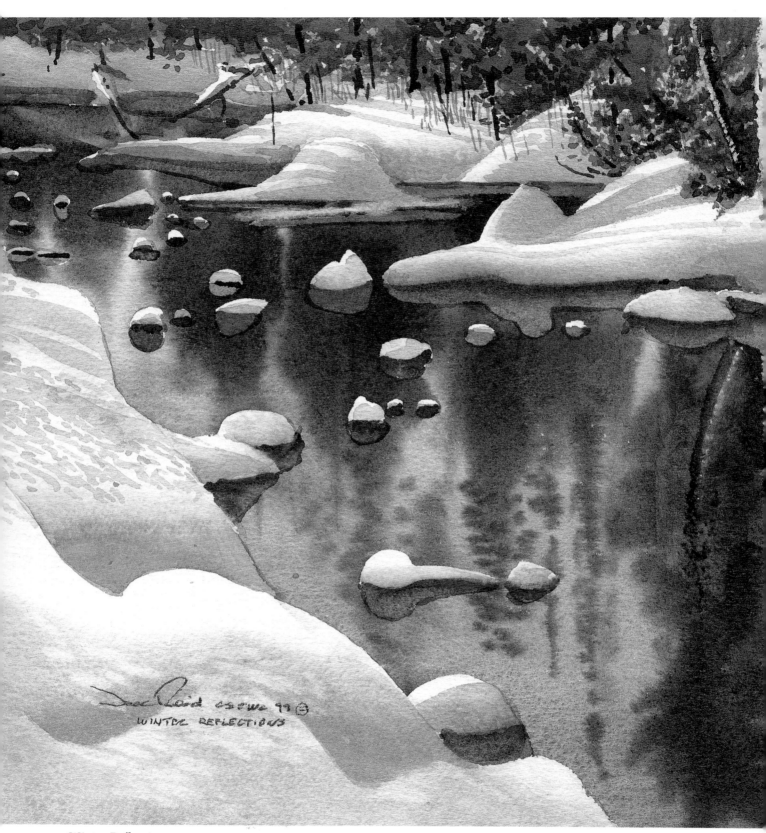

Winter Reflections
11" × 15" (28cm × 38cm)
Watercolor on Arches 300-lb. (640gsm) rough watercolor paper

WATERCOLOR BASICS: PAINTING SNOW AND WATER

JACK REID

![N] **NORTH LIGHT BOOKS**
CINCINNATI, OHIO
www.nlbooks.com

ABOUT THE AUTHOR

Jack Reid has been a full-time watercolor painter since 1970. His award-winning paintings are internationally recognized and can be found at such addresses as Windsor Castle and the Savoy Hotel in England. Reid has imbued more than ten thousand students with a love for the medium of watercolor painting. He continues to instruct amateur and professional painters alike in the basic techniques for which he is renowned.

In 1992 Reid was awarded the Commemorative Medal by the Canadian government for his contribution to the arts. Reid was elected Life Member of the Canadian Society of Painters in Water Colour (CSPWC) in 1998.

Other fine North Light Books are available from your local bookstore, art supply store or direct from the publisher.

04 03 02 01 00 5 4 3 2 1

Library of Congress Cataloging-in-Publication Data

Reid, Jack.
 Watercolor basics. Painting snow and water / Jack Reid.
 p. cm. — (Watercolor basics)
 Includes index.
 ISBN 0-89134-918-9 (pbk.)
 1. Watercolor painting—Technique. 2. Snow in art. 3. Water in art. I. Title.
ND2237 .R45 2000
751.42′2436—dc21 99-054495
 CIP

Edited by Michael Berger
Production edited by Marilyn Daiker and Jolie Lamping
Cover designed by Wendy Dunning
Interior production by Kathy Gardner
Production coordinated by John Peavler
Cover illustration by Jack Reid

DEDICATION

I dedicate this book to the universal living God of my personal understanding without whose grace, love and direction I could not have achieved such a successful and fulfilling personal life and artistic career, and to my best friend and loving wife of thirty-five years, Maggie, who I will always love.

ACKNOWLEDGMENTS

"No man is an island" is a famous quotation which I would paraphrase to say "No one person is an island unto themselves." Although this book is a personal expression of my artistic experience, I too am not an "island" and it would not have been possible without the shared talents of many people.

The first I wish to thank is Jennifer Beale, who encouraged me for many years to write and produce my first book, and who coauthored this one and labored long and hard in completing it. Second I wish to thank Alex Docker and Jim Brown for their creative talents.

And finally I wish to acknowledge the people who worked on the production of this book. Unfortunately it is not possible to list everyone; however, I would be remiss if I failed to thank the following people: Mike Berger, my editor, Rachel Wolf and Pam Wissman, as well as all of the invisible foot soldiers.

Gratefully,

Jack Reid

Elected Life Member of the Canadian
Society of Painters in Water Colour

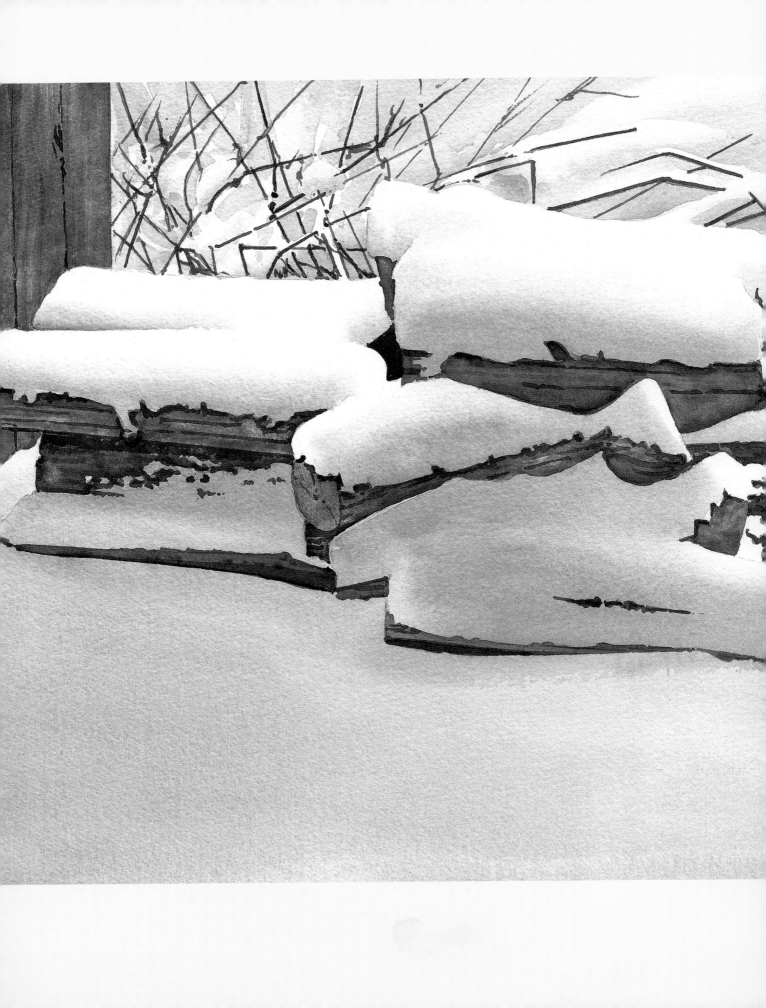

CONTENTS

Fresh Snow on Firewood
14" × 20" (36cm × 51cm)
Watercolor on Arches 300-lb. (640gsm)
rough watercolor paper

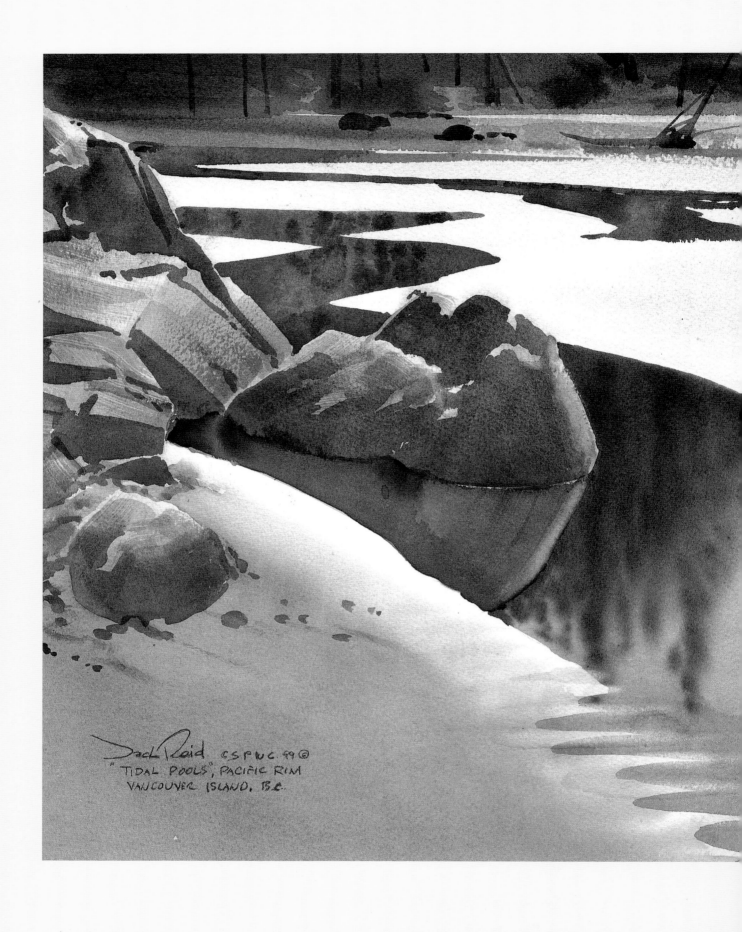

Jack Reid C.S.P.W.C. 99 ©
"TIDAL POOLS", PACIFIC RIM
VANCOUVER ISLAND, B.C.

INTRODUCTION

There are two things in life that, more than anything else, make me feel peaceful and serene: fresh soft falling snow and the gentle sound of falling rain. I paint these two subjects more than any others, so when asked to write a book about painting snow and water in watercolors, naturally I felt great joy and pleasure.

Snow and water are wonderful subjects to paint because they can be found in many forms. There are sunny snowscapes with crisp blue shadows; soft-edged snow banks along a still river; the rushing white water of a turbulent mountain stream; mirrorlike reflections of sky and trees on a northern lake; the mesmerizing crash of breakers on coastal rocks; and much more. And that's exactly what this book is about. It's filled with step-by-step demonstrations that show you how to paint winterscapes and waterscapes in the wonderful medium of transparent watercolors.

Watercolor painting is 90 percent perspiration and 10 percent inspiration, and always in that order. To paint successfully in this tricky medium, you must master the basic techniques and then practice, practice, and don't forget... practice. After teaching more than ten thousand people to paint, I am convinced that you too can paint strong watercolor pictures if you are patient and work hard.

I hope you'll have great success as you take the time to learn to paint in watercolor, and that one day you'll be able to share with me a "joyride in a paint box."

Jack Reid, CSPWC

Tidal Pools
14" × 20" (36cm × 51cm)
Watercolor on Saunders Waterford 300-lb.
(640gsm) rough watercolor paper

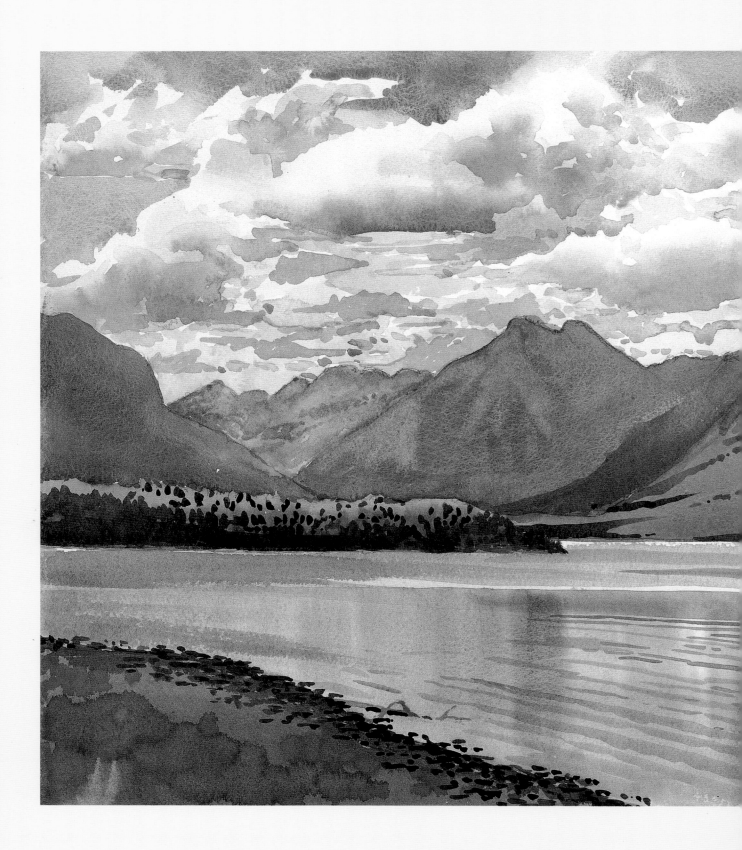

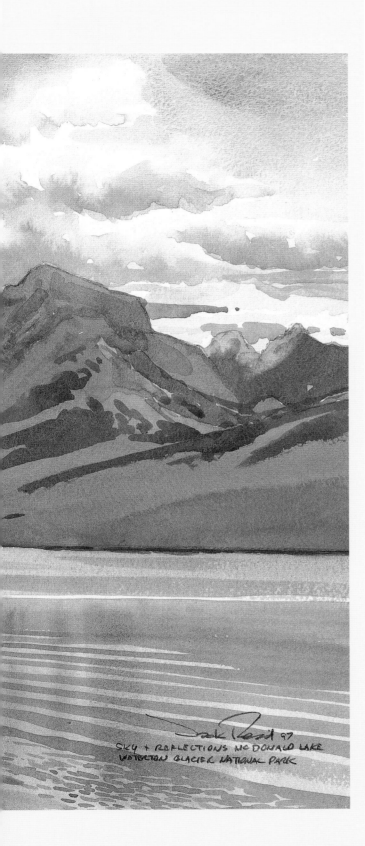

MATERIALS AND TECHNIQUES

ome of the most common questions I get asked by students are, "How do I get started?," or, "What do I need?," or, "How do I use these materials?" Well, this chapter answers those questions. I'll show you what brushes you will need and how to arrange your pigments on your palette. We'll go over the three basic color triads, learn the difference between nonstaining and staining colors, and review the four basic techniques that I use in watercolor painting. Just remember that starting watercolor painting is no different from starting any endeavor—a firm belief in hard work and lots of practice will yield results.

Sky and Water Reflections
14" × 20" (36cm × 51cm)
Watercolor on Saunders Waterford 200-lb. (425gsm)
rough watercolor paper
Collection of Mr. Albert Chou

Brushes

The brushes you'll need are shown life size (approximately) so you can take the book to your art supply store and match the right-sized brushes to the illustration. I've intentionally left out the manufacturers' names because there are many good lines of brushes to choose from. You'll probably find that some companies use strange and somewhat confusing names on the brushes. Don't worry about which manufacturer you choose or what they call their brushes—just buy brushes the same size as pictured here.

The first brush is a 2-inch (51mm) hake. It has a wooden handle and holds an enormous amount of liquid, which makes it ideal for wetting paper, laying large washes, and also for lifting excessive wetness.

The second brush is called a 1-inch (25mm) square brush. It too is ideal for wetting paper and laying washes. The third brush is the smaller ½-inch (12mm) square brush. I use both of these for painting square objects, such as chimneys, windows, buildings and so forth. The fourth brush is a no. 12 show card lettering brush. It

looks round but has a flat edge like the square brushes. This brush is not a watercolor brush, but over the years I've found it excellent for painting long lines, such as trees and fence posts, because it holds lots of paint.

The next three are called round brushes, and they're ideal for painting round or pointed objects. You'll need a no. 12 or 14, a no. 6 or 8 and a no. 4 round brush (not shown). The next brush is a no. 3 rigger. With its long tapered hairs and thin tip, it's well suited to paint long tapered subjects, such as grass or a wire fence.

The next two are scrub brushes. These are oil, not watercolor, brushes and you will need to cut or sandpaper the bristles short, on an angle, before you use them. I use these for scrubbing areas of pigments just prior to lifting them away with a tissue.

The final brush is a no. 10 or 12 round with a worn tip. It's excellent for drybrushing. If you do not have an old worn brush, you can buy a new brush and rub the tip with sandpaper.

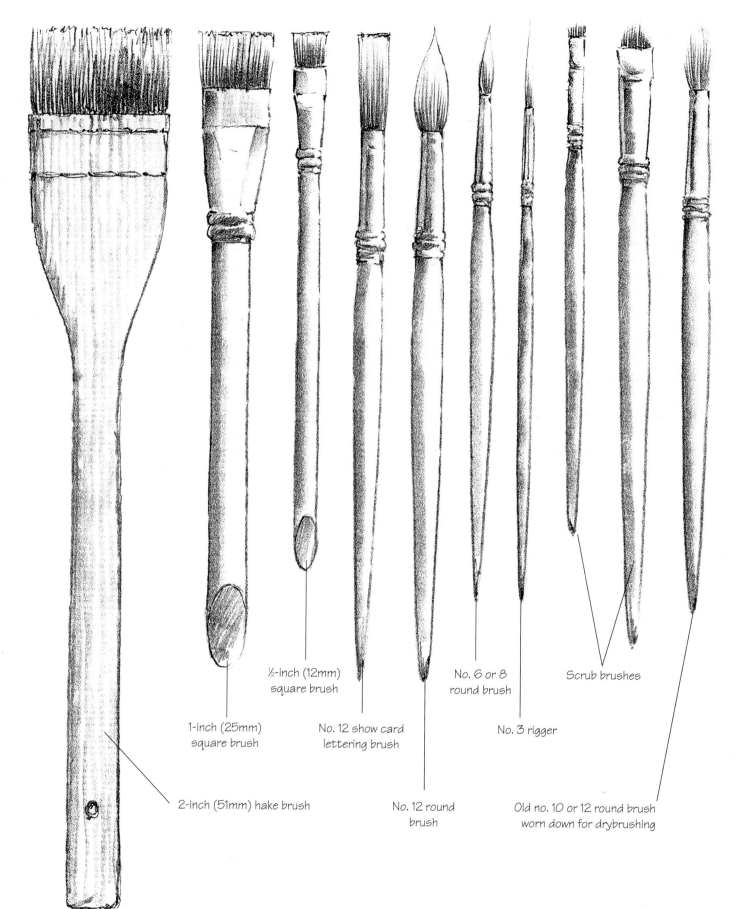

2-inch (51mm) hake brush

1-inch (25mm) square brush

½-inch (12mm) square brush

No. 12 show card lettering brush

No. 12 round brush

No. 6 or 8 round brush

No. 3 rigger

Scrub brushes

Old no. 10 or 12 round brush worn down for drybrushing

Paper

Good quality paper is expensive, but serious watercolorists always use 100 percent rag, mould-made paper. I recommend you don't skimp on paper. If you buy a heavy-weight paper that won't buckle, you can count on getting reliable results every time. There are many brands of quality paper, such as Arches, Fabriano, Saunders, Strathmore and Winsor & Newton, to name just a few. As you will notice in the following chapters, I use many different brands of paper. However, I paint mostly on Arches paper.

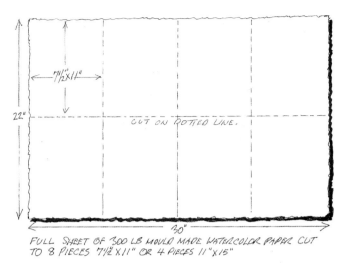

FULL SHEET OF 300 LB MOULD MADE WATERCOLOR PAPER CUT TO 8 PIECES 7½"X11" OR 4 PIECES 11"X15"

To save money, I recommend you purchase a large sheet (22" × 30" [56cm × 76cm]) of 300-lb. (640gsm) paper and cut it into eight smaller 7½" × 11" (19cm × 28cm) pieces. Remember you can always paint on both sides.

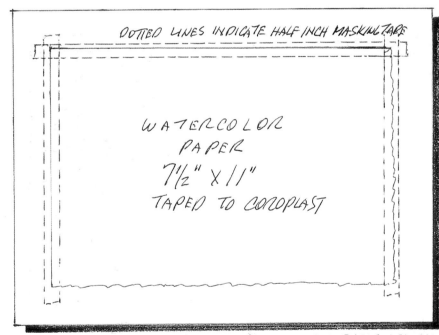

TAPE IS TO HOLD PAPER IN POSITION, THREE SIDES ARE OK

Tape your watercolor paper down on three sides to prevent it from slipping while you work. Also, the tape will allow for a margin on all sides.

Paper Blocks

You can buy watercolor paper in blocks, which is very convenient, but still quite expensive. A block usually has about fifteen to twenty sheets of 140-lb. (300gsm) paper gummed on four sides. But because it's only 140 lb., it will tend to buckle. If you plan to go this route, buy small-sized blocks about 7" × 10" (18cm × 25cm) to keep the buckling to a minimum.

Palette

I will now explain my palette, how I set it up, what colors I use and why. I should point out that the brand is not as important as the quality. Always buy artist-quality, not student-grade, pigments. Student-quality pigments will never give you good results.

At first, I recommend you lay out the palette in the unconventional manner you see below, according to pigment group characteristics, not color groups. The first group are transparent nonstaining colors, and include Rose Madder Genuine, Aureolin Yellow, Cobalt Blue, Viridian Green, Burnt Sienna and Raw Sienna. Ultramarine Blue is my one granular nonstaining color.

These pigments are luminous and lay on the surface of the paper without penetrating it. Because of this behavior, they can be removed almost completely from the paper when desired by agitating with a scrub brush and clean water.

They can also be glazed, or painted over, any number of times as long as they are perfectly dry and you work quickly. And they will retain their luminosity.

The rest of the pigments are transparent staining pigments and include Thalo Green, Thalo Blue, Transparent Yellow, Alizarin Crimson and Permanent Rose. These pigments penetrate and stain the paper. Once used, you cannot completely remove them without leaving some pigment behind. They do not glaze well. When water is applied to the first layer, it revives the color and will mix with the second wash, resulting in muddy colors. For the time being, just pass on the staining pigments.

Throughout the book we will use only the nonstaining pigments. I've listed the others simply to help you understand that some pigments are nonstaining and some are staining.

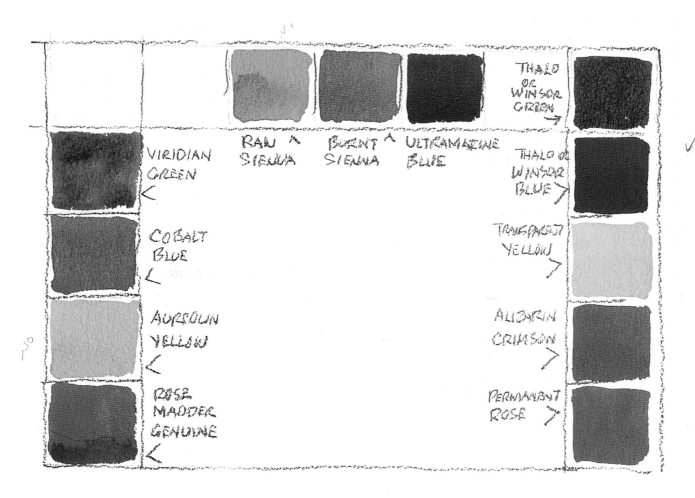

VIRIDIAN GREEN

COBALT BLUE

AUREOLIN YELLOW

ROSE MADDER GENUINE

RAW SIENNA

BURNT SIENNA

ULTRAMARINE BLUE

THALO OR WINSOR GREEN

THALO OR WINSOR BLUE

TRANSPARENT YELLOW

ALIZARIN CRIMSON

PERMANENT ROSE

Color Combinations

Notice in the center of each triad I've painted a black produced from equal parts of the three colors. I've scrubbed and lifted the black to show you how easy nonstaining pigments lift from paper, and how difficult staining pigments lift.

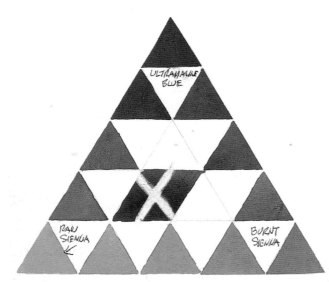

TRIAD ONE—NONSTAINING COLORS
Raw Sienna, Burnt Sienna and Ultramarine Blue can be mixed in a number of ways to produce other subdued earth-tone colors.

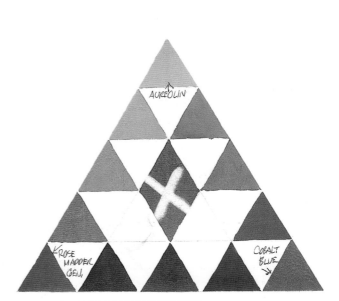

TRIAD TWO—NONSTAINING COLORS
Rose Madder Genuine, Aureolin Yellow and Cobalt Blue are primary colors. Theoretically they can be mixed to produce all other colors. Here I've combined them to produce secondary colors.

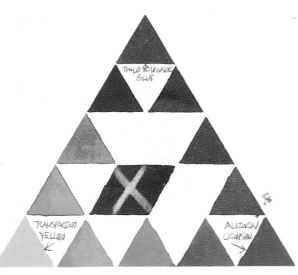

TRIAD THREE—STAINING COLORS
Thalo Blue, Transparent Yellow and Alizarin Crimson have been combined to produce a number of colors.

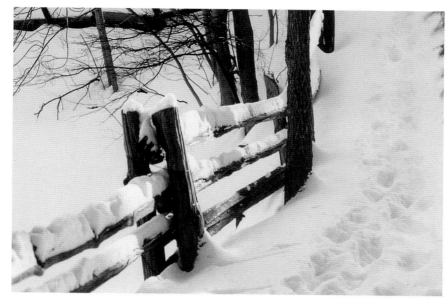

DETERMINING WHAT COLOR COMBINATION TO USE
When determining what my palette will be, I often use a photograph to help establish my composition and determine what the mood will be.

ONE POSSIBILITY
Here's a painting based on the photo above. It was done with a palette consisting of Rose Madder Genuine, Aureolin Yellow, Cobalt Blue and Viridian Green. The result is a simple composition with the fence as a focal point.

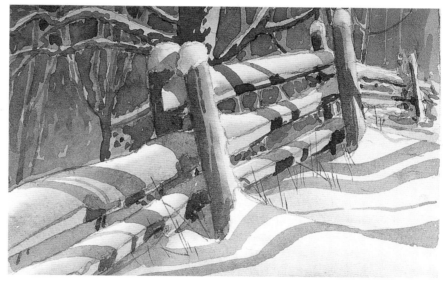

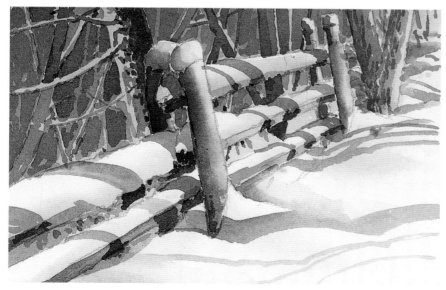

A SECOND COLOR COMBINATION
Here's the same scene after a fresh snowfall. The palette here consisted of Raw Sienna, Burnt Sienna and Ultramarine Blue. Notice how different the mood seems by using a different color combination.

Four Basic Watercolor Techniques

Here's a quick refresher course on the four basic techniques of watercolor painting. For more practice, turn to my first book, *Watercolor Basics: Let's Get Started* (North Light Books, 1998).

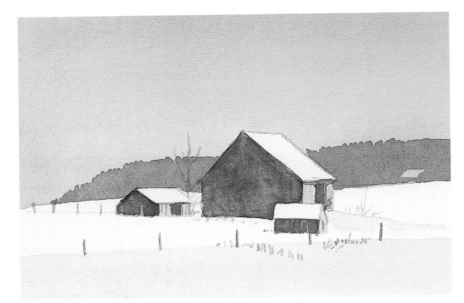

Flat Wash:
one color painted over part or all of the painting.

Graded Wash:
a field of color that gradually fades away or gets stronger depending on how you look at it.

FLAT WASH
In the painting above, I painted a series of flat washes for the barn and other buildings in a snow-covered field.

GRADED WASH
In this picture to the right, I painted a flat wash for the barn and then graded washes for the sky and the two banks of snow.

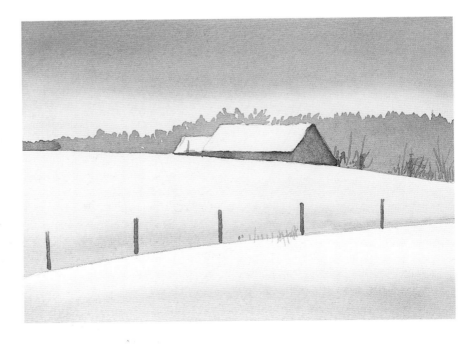

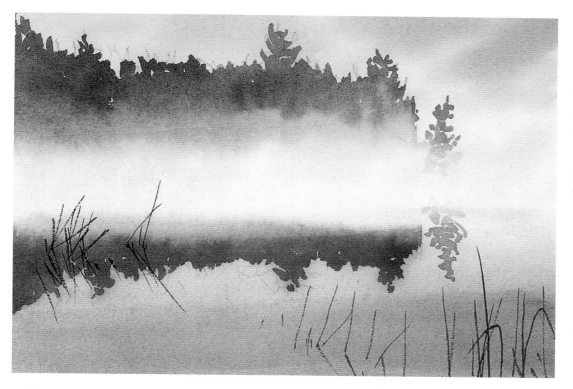

In this painting, I painted wet-in-wet for the sky and water and a graded wash for the mist. In the foreground I also indicated reeds sticking through the water and their reflections.

Wet-in-Wet:
applying wet paint to wet paper.

Drybrushing:
painting with a brush that is almost empty, and as you drag it across the paper, you create a mottled effect.

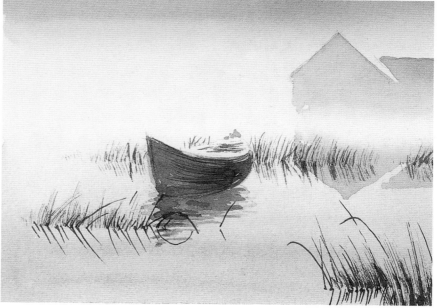

DRYBRUSH
After painting a graded wash from the top down through the water, I added some drybrush to the texture of the boat, as well as the rushes in the foreground and behind the boat.

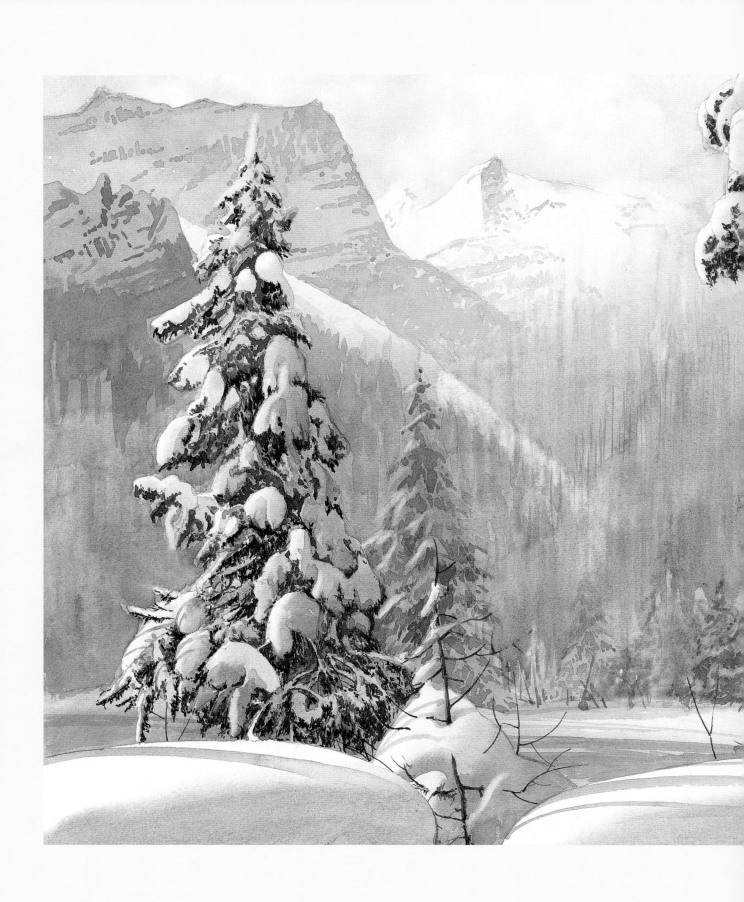

SNOW

Transparent watercolors are a powerful medium for expressing the feelings of translucent, transparent snow. With just a few colors you can create an illusion of softness, hardness or brightness.

Great snow paintings happen when you utilize the power of the white paper. How do you achieve this? By spending hours painting tiny white dots on white paper with a little brush that has only four hairs? I guess you could, but that's not how I like to paint. Instead I suggest you reduce the amount of white paper left; the less white paper, the more powerful the white becomes. How much white should you leave? Again, there's no easy answer. It really depends on the effect you're trying to create.

The lessons in this chapter demonstrate many aspects of snow, such as heavy snow, falling snow, fresh and drifting snow. We'll be using limited palettes with, for the most part, just two or three pigments.

Now, let's begin. I think you'll find these lessons challenging, but not impossible. And I hope as you practice painting snow, it brings you as much joy as it has to me. Good luck.

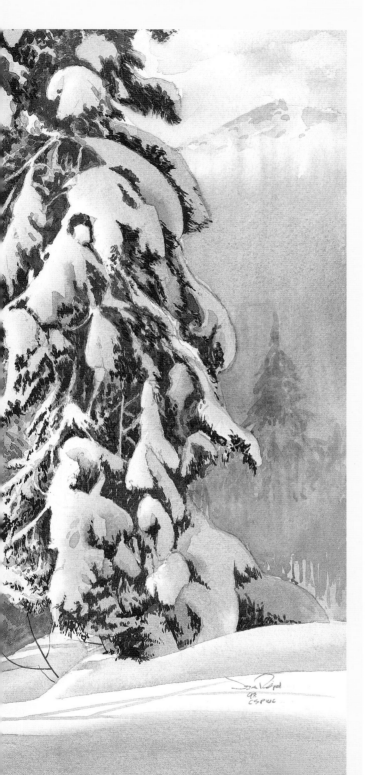

Snow Sculptures
18" × 24" (46cm × 61cm)
Watercolor on Arches 300-lb. (640gsm)
rough watercolor paper
Collection of Mrs. Maggie Reid

Painting Shadows on Snow

Colors bounce around when they hit snow, and they tend to become exaggerated, seen as colors that don't really exist. This Quebec scene shows the power of placing rather dull-colored buildings next to a luminous-colored sky, thus suggesting both strong sunlight and shadows. Keep in mind the colors in the palette that hold those luminous qualities: Rose Madder Genuine, Aureolin Yellow and Cobalt Blue.

Palette
Aureolin Yellow
Burnt Sienna
Cobalt Blue
Rose Madder Genuine
Ultramarine Blue
Viridian Green

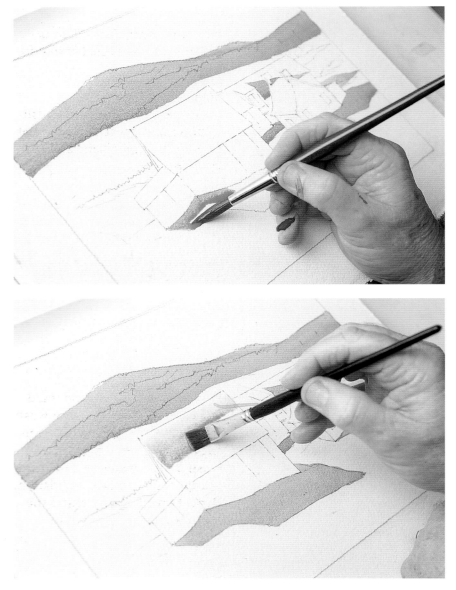

Step 1
Mix a purple-blue wash with Rose Madder Genuine, Aureolin Yellow and Cobalt Blue. Using a ½-inch (12mm) square brush, paint the distant hills, as well as the shadows between the buildings.

Step 2
Use the same purple-blue mix and paint a graded wash on the roof of the building. Let dry.

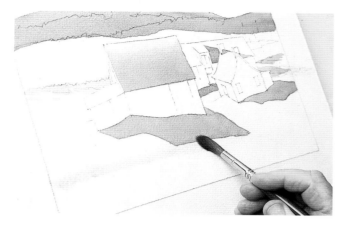

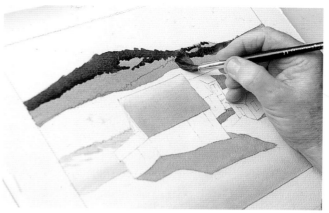

Step 3
Continue with the same mix and paint a graded wash in the foreground.

Step 4
Mix a wash of Ultramarine Blue, Burnt Sienna and Viridian Green. Paint the tree line behind the hill, carrying it down the hill.

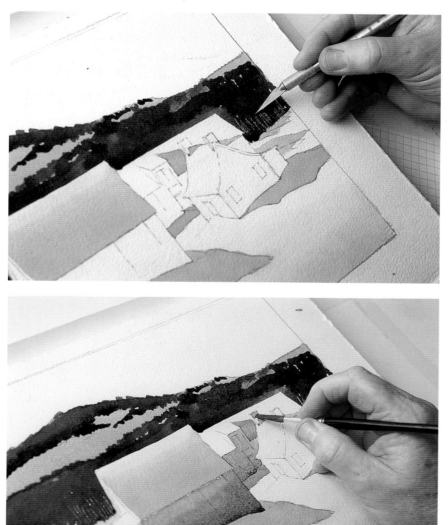

Step 5
Score the wet paint with a utility knife to suggest the trunks of trees on the right-hand side of the barn.

Step 6
In the closest part of the main barn, paint a Burnt Sienna wash using a no. 12 show card lettering brush. Charge this with a wash of Burnt Sienna and Ultramarine Blue to create a gradation. Repeat on the barn behind the main barn.

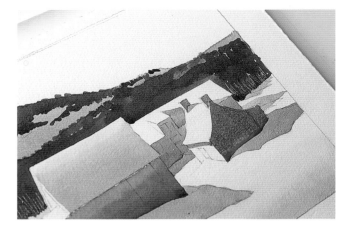

Step 7

Mix Burnt Sienna, Ultramarine Blue and Rose Madder Genuine. With the no. 12 show card lettering brush, paint the main structure, boards and windows of the house. Add a pink tinge of Rose Madder Genuine to the base of the house.

Step 8

Mix a luminous yellow-orange wash from mostly Aureolin Yellow and Rose Madder Genuine. Place the picture upside down and paint the yellow-orange wash quickly across the sky. Mix a gray-brown wash for clouds by adding Cobalt Blue. Turn the picture sideways, and with a no. 8 round brush and wet-in-wet, brush clouds in the sky.

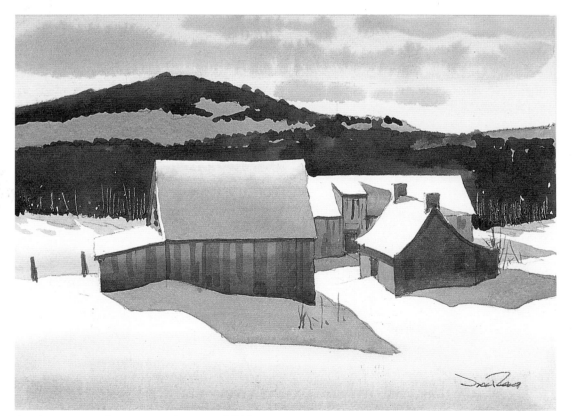

Quebec Barn and House in Snow at Twilight
9" × 12" (23cm × 30cm)
Watercolor on Fabriano 300-lb. (640gsm)
cold-pressed watercolor paper

Painting Heavy Snow

I often used to sit on this bench in our backyard by the pond even in the snow. In this painting I've achieved strength by contrasting the shocking white snow against the dark trees behind the bench. The weeds poking through the snow, painted with a no. 3 rigger, complete the picture. Be careful you don't get "rigger remorse." That happens when people get picky with the rigger and paint far too many details.

Palette
Burnt Sienna
Cobalt Blue
Raw Sienna
Ultramarine Blue

Step 1
Mix a luminous gray wash from Cobalt Blue and Burnt Sienna. Set it aside for a minute. Take a no. 12 round brush and, using very clean water, paint a graded wash on the left-hand side around the top of the snow-covered bench.

Step 2
Turn the painting right side up. With the same gray wash, paint the shadow under the bench.

Step 3

Deepen the wash and paint a graded wash along the edge of the bench. Start with clear water and add pigment to create a soft gray. This is a bit tricky, so take your time and pay attention; it's very rewarding once you bring it off.

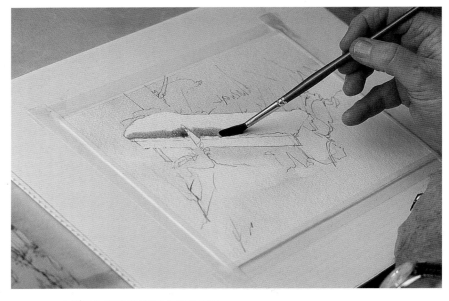

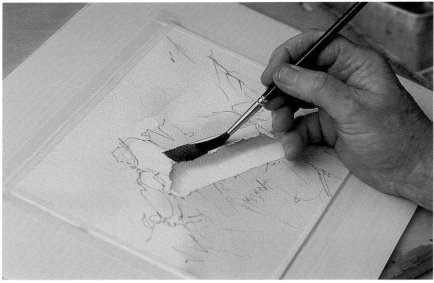

Step 4

Now mix a brown wash from Burnt Sienna and Ultramarine Blue. Using the no. 12 show card lettering brush, paint the horizontal top of the bench up to the edge of the snow. Leave a bit of white on the snow-covered bush in front of the bench.

Step 5

Create a wood-grain texture on the bench by scoring the wet paper with a utility knife.

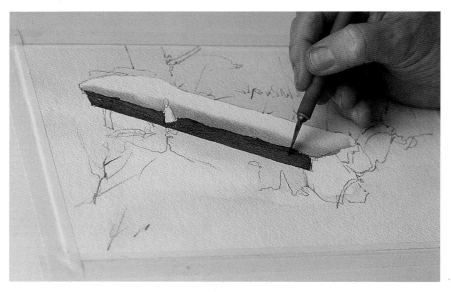

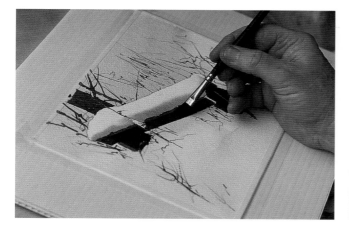

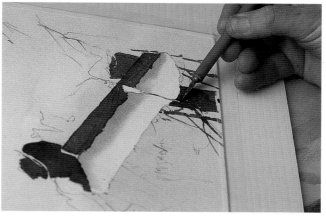

Step 6

With the no. 12 show card lettering brush and the brown mix, paint the exposed parts of the bench, leaving white space for weeds, as shown. Also paint the tree trunk. Notice how the brown background causes the snow on top of the bench to stand out.

Step 7

Suggest the texture of bark on the tree by scoring the paper with a sharp knife while the paper is still wet. Add Burnt Sienna to the wash, and using a no. 3 rigger, paint dried grasses.

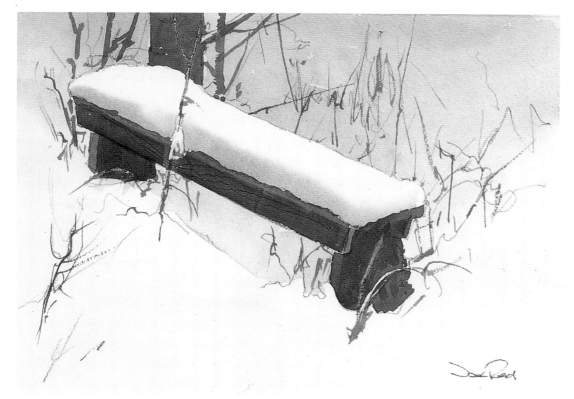

Snow-Covered Bench
7" × 10" (18cm × 25cm)
Watercolor on Saunders Waterford 300-lb. (640gsm)
rough watercolor paper

Painting Light Snow

If you painted this picture properly, you'd be a liar! What I mean is by painting the sky gray and leaving the field white, you'd be suggesting a dimension when in fact there isn't any dimension at all. This painting also demonstrates the power of drybrush. I drybrushed the stubble quickly and spontaneously, and it contrasts nicely with the soft edge of the tree line.

Palette
Burnt Sienna
Ultramarine Blue

Step 1
Mix a light-value gray wash with Ultramarine Blue and Burnt Sienna. Turn the paper upside down and paint a flat wash for the gray sky to about halfway down.

Step 2
Deepen the wash, and while the sky is still wet, with a dry ½-inch (12mm) square brush, paint quickly a soft tree line across the page.

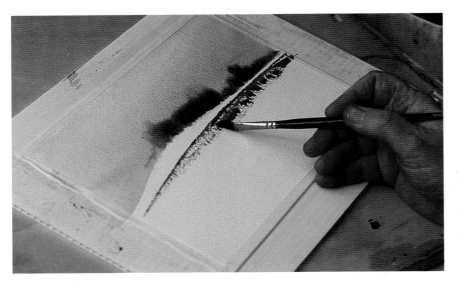

Step 3
With the deepened gray mix and the same brush, tilt the brush on an angle and stroke across the center of the paper, until you run out of paint.

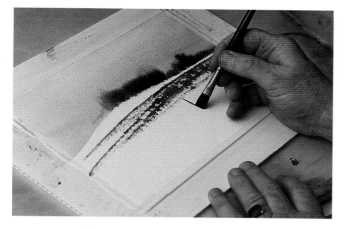
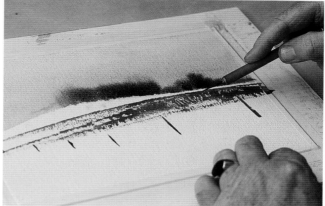

Step 4
Continue using the same deep-value gray mix and ½-inch (12mm) square brush to paint fence posts.

Step 5
When the painting has dried, use a utility knife to scrape away some of the paint in the stubble area.

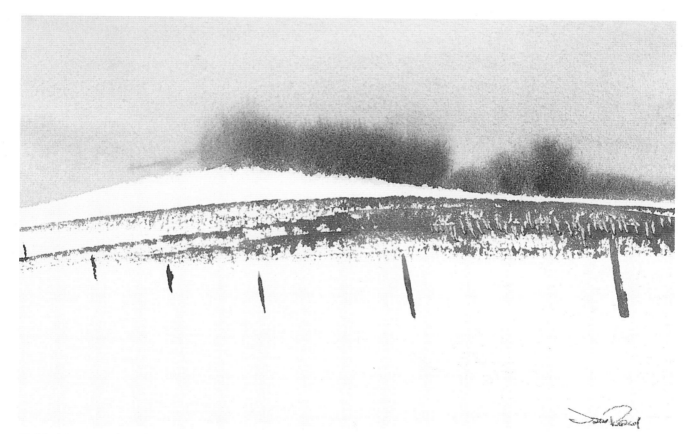

Field of Snow With Stubble
7½" × 11" (19cm × 28cm)
Watercolor on Winsor & Newton 260-lb. (550gsm)
watercolor paper

Painting Falling Snow

One snowy day many years ago, I walked my dogs in a nearby field. The snow blurred everything and I remember wondering, what would be the best way to paint falling snow. The most important thing, I soon discovered, was to keep things simple. In this case, simplicity is two or three simple graded washes on the cluster of trees in the left foreground, a wash that suggests drifting snow, and everything in the picture diffused.

Palette
Burnt Sienna
Cobalt Blue
Raw Sienna
Ultramarine Blue

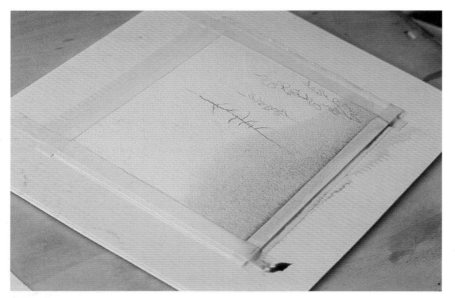

Step 1
Mix a soft gray wash of Cobalt Blue and Burnt Sienna. To create the illusion of distant trees disappearing just off to the right, turn the picture upside down and using a 2-inch (51mm) hake, wet the entire piece of paper with clean water. Still using the hake, carry the wash right across the paper. Because the paper is upside down, the paint will run toward you.

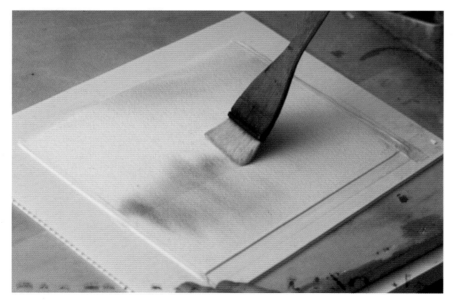

Step 2
While the paper is still wet, deepen the gray wash. With the 2-inch (51mm) hake, blast in the impression of a distant tree line.

Step 3
Still with the paper upside down, deepen the wash again. Switch to a ½-inch (12mm) square brush and strengthen parts of the tree line.

Step 4
Turn the picture right side up. Sweep a graded gray wash under the tree line, across the foreground on the left-hand side of the picture.

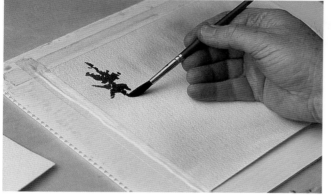

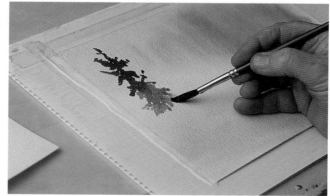

Step 5
Mix a dull gray wash with Ultramarine Blue, Burnt Sienna and Raw Sienna. With a no. 8 round brush, paint the spruce tree, working quickly from the top down. As you reach the bottom, make a graded wash by adding water. Then quickly paint in the second tree on the right. With a tissue, move quickly and lift some of the paint (as shown in the bottom right photo) to create the illusion of snow drifting up in a cloud in front of it. Let dry.

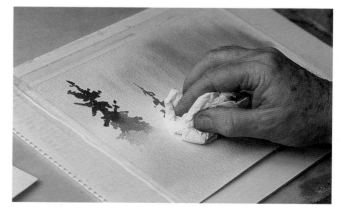

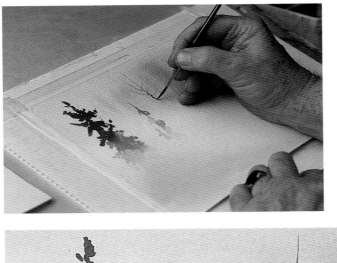

Step 6
Mix a gray wash with Burnt Sienna and Ultramarine Blue. Using a no. 3 rigger, paint the standing dead tree to the middle-right and then a couple more in the distance. Again create the illusion of the trees disappearing in drifting snow by lifting color from the base of the tree with a tissue.

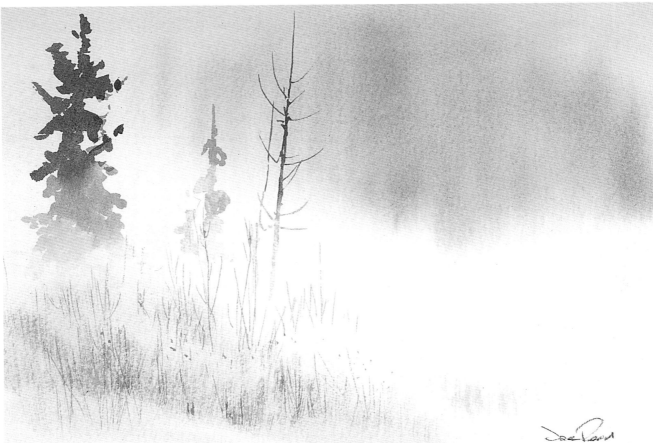

The Illusion of Falling Snow
7½" × 11" (19cm × 28cm)
Watercolor on Arches 300-lb. (640gsm)
watercolor paper

Lifting Nonstaining Pigments
You can lift nonstaining pigments by wetting the area with clean water, agitating it with a scrub brush and lifting with a tissue, but only when you're painting on good quality paper.

Painting Drifting Snow

In this painting there's a lot of white paper left; it's a classic example of less is more. It exemplifies an unforgettable statement one of my students once made about painting snow: "It's the incredible economy of pigment, paper and motion."

To keep your paper from buckling when working wet-in-wet, you must use a heavy-weight paper (preferably 300 lb. [640gsm]).

Make Sure Your Paper Is Dry When Glazing
All watercolor is soluble after it dries. When you're glazing nonstaining pigments, make sure the paper is perfectly dry first. Paint your strokes quickly and briskly. You probably won't get it perfect the first time, but keep at it. Sooner or later you will.

Step 1
Using a 2-inch (51mm) hake, wash the paper with clean water and let settle for a few moments. Mix a light gray wash using Burnt Sienna and Ultramarine Blue. Switch to a 1-inch (25mm) square brush and lay the gray wash for the sky. While still wet, deepen the wash and paint a blurred tree line in the right corner.

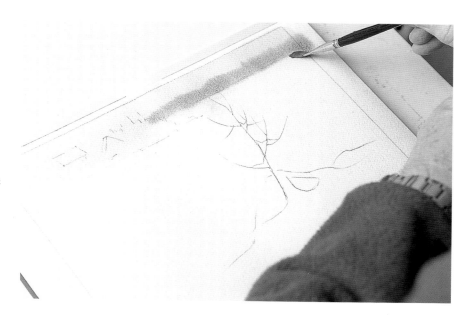

Step 2
Use various values of the gray wash to define the snow shadows at the base of the tree in the foreground. Then, tip the picture on its side to let the washes run slightly.

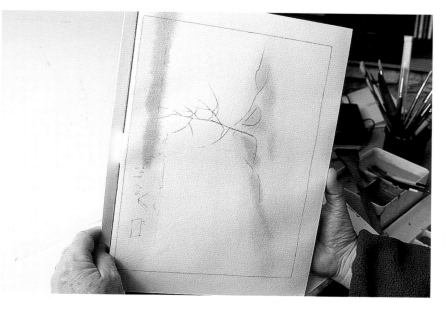

Palette
Burnt Sienna
Raw Sienna
Ultramarine Blue

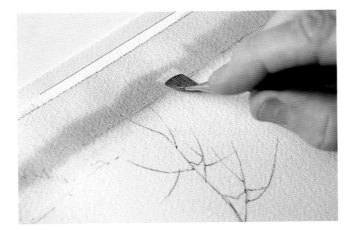

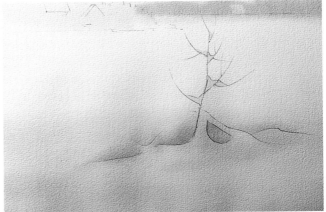

Step 3

Squeeze together the bristles of a ½-inch (12mm) square brush until they are almost dry. Then press the brush against the semiwet tree line in the top right corner. This will lift some of the paint and create the illusion of a snow-covered barn in the distance.

Step 4

At this point, I decided the shadows surrounding the tree base should be darkened. To do this, first glaze the area just above the shadow with clean water. Then carry a graded blue-gray wash to the bottom of the paper, wiping the beaded edge. When dry, the painting will look like this.

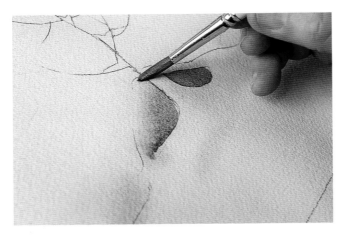

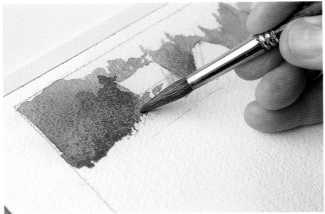

Step 5

Use the same wash and glaze over the shadows surrounding the tree, as well as around the grass and tree.

Step 6

Mix a soft brown-gray wash using Burnt Sienna and Ultramarine Blue. Use a no. 8 round brush to paint the background trees and buildings, leaving the roofs white. Deepen the wash by adding some Burnt Sienna and glaze over the exposed portion of both buildings. Then brush beside the buildings to suggest cedar trees.

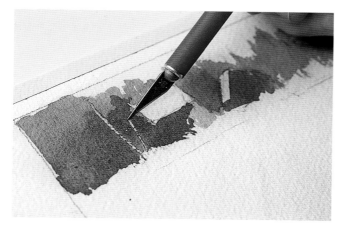

Step 7

While the paper is still wet, score with a utility knife to indicate white birch trees. Remember: Don't do this too quickly or you'll get a dark tree, not a light one—unless, of course, you want a dark tree.

Step 8

Mix orange-brown wash using Burnt Sienna, Raw Sienna and Ultramarine Blue, with emphasis on Raw Sienna. Turn the painting to a comfortable angle and use a no. 3 rigger to suggest grass. Add some Burnt Sienna and Ultramarine Blue to make a brown wash and paint in a sapling.

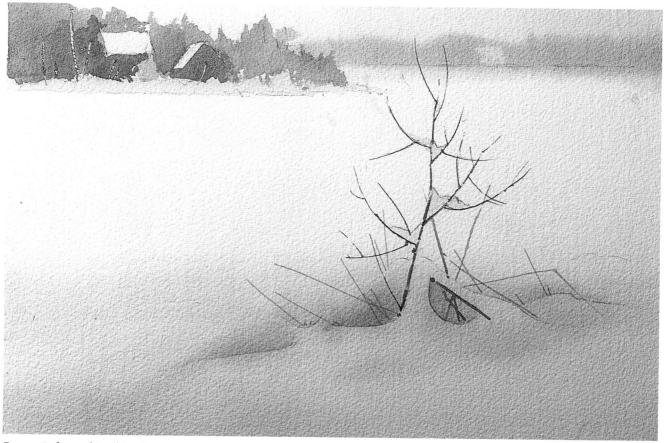

Frozen Lake and Drifting Snow
9" × 12" (23cm × 30cm)
Watercolor on Arches 140-lb. (300gsm) rough watercolor paper

Painting Snow on Pine Branches

In this painting, notice how the graded washes soften the heavy snow hanging on the pine bough, bending it over until it almost touches the ground. Notice also how the graded washes on the bough create the illusion of roundness. Because what little white is left contrasts so strongly with the flat gray background, the edges of the bough become very powerful.

Palette
Burnt Sienna
Cobalt Blue
Viridian Green

Step 1
Mix a soft blue-gray wash using Cobalt Blue and Burnt Sienna. For the sky, lay a flat wash, painting carefully around the bough. Near the bough, soften the edge by adding water to the wash.

Step 2
While still wet, mix a light brown wash using Cobalt Blue and Burnt Sienna, and paint the distant tree line.

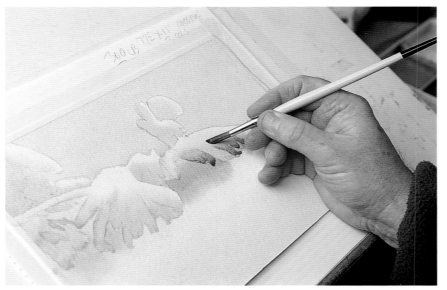

Step 3
Mix a blue-gray from Cobalt Blue and Burnt Sienna. Create depth and detail in the bough by applying a series of blue-gray graded washes with a no. 8 round brush. Begin the wash with clean water and finish with the blue-gray wash.

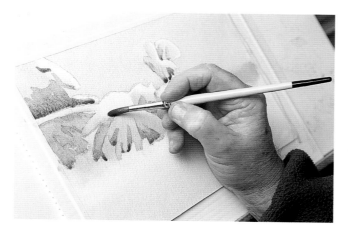

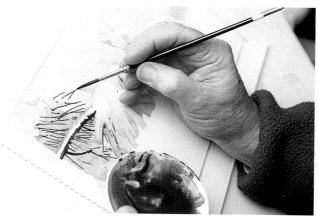

Step 4
Darken the blue-gray wash slightly and wash in dark shadow areas under the bough.

Step 5
Mix a dark brown wash using Cobalt Blue and Burnt Sienna. Using a no. 8 round, paint the exposed areas of the bough. Now, create a dull tertiary green by adding Viridian Green to the wash. With a no. 3 rigger, complete the picture by painting pine needles sticking through the snow.

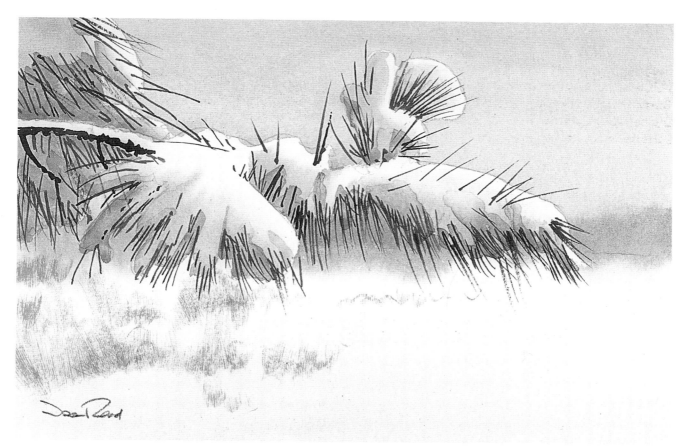

Heavy Snow-Laden Pine Bough
7½" × 11" (19cm × 28cm)
Watercolor on Arches 300-lb. (640gsm) rough watercolor paper

Painting Snow on Plants

The most important aspect of this painting is the graded washes on the white bumps of the plants. Notice the visual power produced by the white tops reduced by the soft edges of each teasel. Painting around the white tops can be challenging, but if you mask them, they'll become stiff and hard-edged.

Palette
Burnt Sienna
Cobalt Blue
Raw Sienna

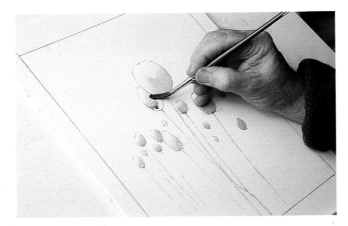

Step 1
Wash the fronts of the teasels with clean water, leaving the very top portion dry, which will remain pure white. Mix a medium-value soft gray wash from Cobalt Blue and Burnt Sienna, and paint the fronts of the teasels using a graded wash. Let dry.

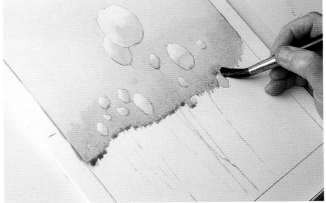

Step 2
Lay a clear water wash across the sky area. Then, using the same soft gray wash and wet-in-wet, paint the sky. Remember to paint carefully around the white teasel shapes. Let dry.

Deepen the gray wash and glaze over the sky. The deep gray sky will contrast nicely with the white teasel caps.

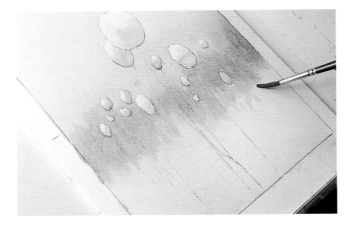

Step 3
Using the same gray mix, start a graded wash about two-thirds of the way down the paper. As you go, lighten the value by adding water, and continue to the bottom of the paper. Then quickly, while the paper is still wet, add Burnt Sienna to indicate distant grasses behind the teasels.

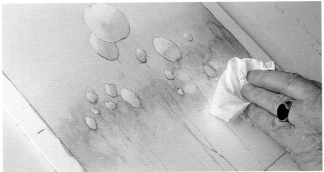

Step 4
Blur the snow and grass slightly by lifting parts of the Burnt Sienna wash with a tissue. Let dry.

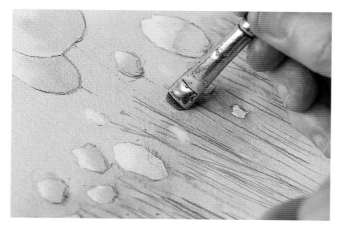

Step 5

With a scrub brush and clean water, create random impressions of other teasels in the background. Lift with a tissue.

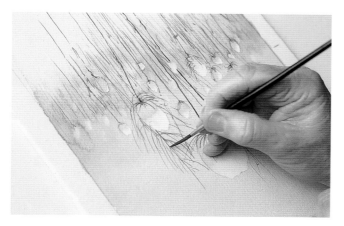

Step 6

With a no. 3 rigger, define the grass using a wash of mostly Raw Sienna, with a touch of Burnt Sienna and Cobalt Blue. Allow to dry, and then mix a thick dark brown wash using Raw Sienna, Burnt Sienna and Cobalt Blue. Using the rigger, paint details of teasel stems and patterns of other weeds; you can substitute other favorite wildflowers if you wish. If I've put in too many elements for your taste, simplify the picture to your liking.

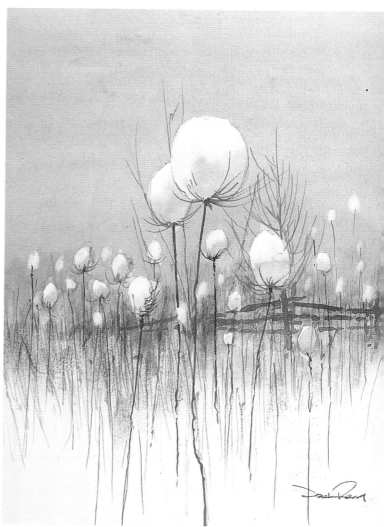

Snow Covered Teasels and Weeds
12" × 9" (30cm × 23cm)
Watercolor on Saunders Waterford 200-lb. (425gsm) cold-pressed watercolor paper

Don't Use Masking Fluid
If you use masking fluid instead of painting around an object, you'll get a hard edge instead of a soft edge. Masking fluid requires careful handling and can destroy a decent brush.

Painting Snow on Objects

When painting snow on objects, the idea is to say a lot with a little. The two features that make this painting work are the soft edge at the top of the barrel, and the soft shadows around it. Notice how well the snow on top of the barrel stands out. This is a good example of how, when you reduce the amount of white, the remaining spot becomes extremely powerful.

Palette
Burnt Sienna
Ultramarine Blue

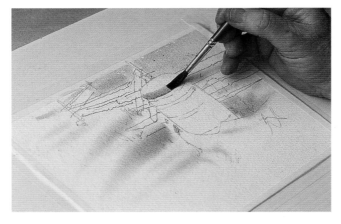

Step 1
Wet the paper completely except for the barrel. Mix two washes: a blue-gray wash with predominately Ultramarine Blue and Burnt Sienna and a dark brown wash with predominately Burnt Sienna and Ultramarine Blue. Reduce the value of the gray wash with water. Starting on the left-hand side of the barrel, use the no. 12 show card lettering brush to paint a graded wash for the snow on the barrel top.

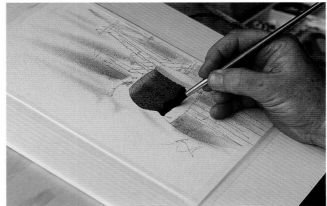

Step 2
Using the dark brown wash, paint the side of the barrel. On the right-hand side of the barrel, paint a stroke of pure Burnt Sienna. Let dry.

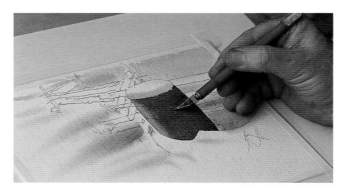

Step 3
While the paint is wet, score the side of the barrel with a utility knife to indicate stains.

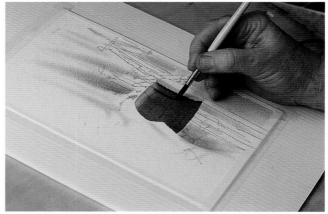

Step 4
Mix a rusty brown wash from Burnt Sienna and Ultramarine Blue. Using the no. 12 show card lettering brush, paint metal bands on the edge of the barrel.

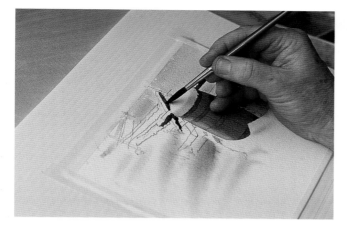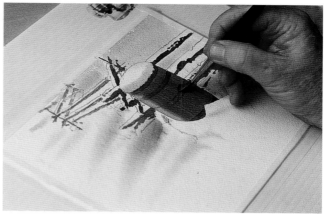

Step 5
Using the same dark brown wash as for the barrel, paint the exposed parts of the fence.

Step 6
Load your ½-inch (12mm) square brush with dark brown wash, and then proceed to wipe off most of the paint on a separate piece of paper. Now dry-brush the suggestion of foliage behind the fence. Notice how I've carefully painted around the top of the barrel, leaving it stark white—a very strong center to the painting.

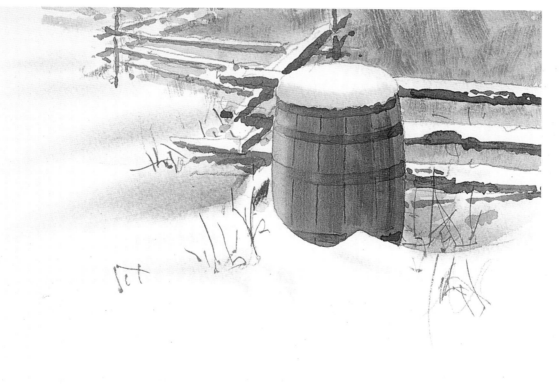

Barrel and Fence in Snow
7½" × 11" (19cm × 28cm)
Watercolor on Arches 300-lb. (640gsm)
watercolor paper

Painting Fresh Snow

I awoke to this particular scene one morning. It was early dawn and just a bit of morning light broke across the horizon. I was so moved by the emotions I felt that right away I wanted to get the image down in paint. The trick to this painting is to work fast. Get the image clear in your mind, and move along as quickly as you can.

Palette
Burnt Sienna
Cobalt Blue
Raw Sienna

Step 1
Mix a soft gray wash with Cobalt Blue and Raw Sienna. Starting at the top left and using a 1-inch (25mm) square brush, lay in a couple of rows of a flat wash for the sky. Finish with one row of clear water across the paper to blur the edge.

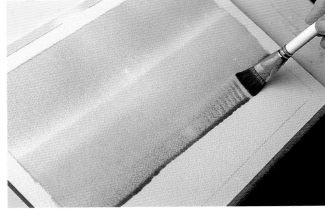

Step 2
Next, mix a pure wash of Raw Sienna and continue the flat wash for several rows along the center of the paper.

About two-thirds of the way down, using the same gray wash as for the sky, cover the foreground, blending the crossover row with Burnt Sienna. Be sure to lift off the beaded edge at the bottom of the page so you don't get a back run.

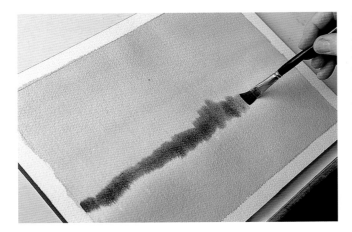

Step 3
Mix a darker-value gray wash of Cobalt Blue and Burnt Sienna and, while the foreground is still wet, quickly wash in a tree line. Shake your hand slightly as you stroke. Then deepen the same wash slightly and brush in the foreground trees.

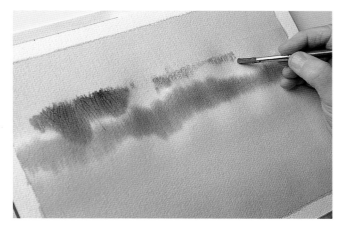

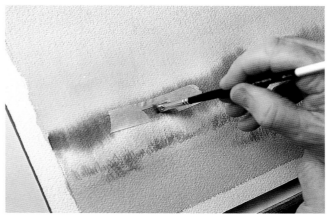

Step 4
Turn the painting upside down, and using Raw Sienna and a no. 4 or 8 round brush, splay the brush tip and drybrush some grass beside the tree in the foreground.

Step 5
To complete the picture, create the impression of a barn roof in the distance. First make sure the painting is completely dry. Then take a piece of ¾-inch (2cm) masking tape, cut out the shape of the roof and tape it over the background tree line. Using a stiff scrub brush and clean water, rub briskly over the roof pattern, quickly lifting the paint with a tissue. Don't worry if some paint runs under the tape.

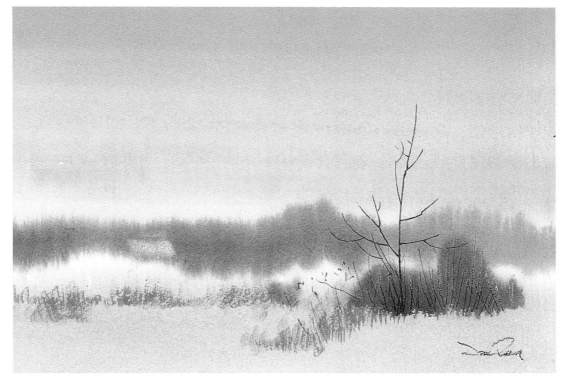

Soft Winter Light
9" × 12" (23cm × 30cm)
Watercolor on Arches 140-lb. (300gsm)
rough watercolor paper

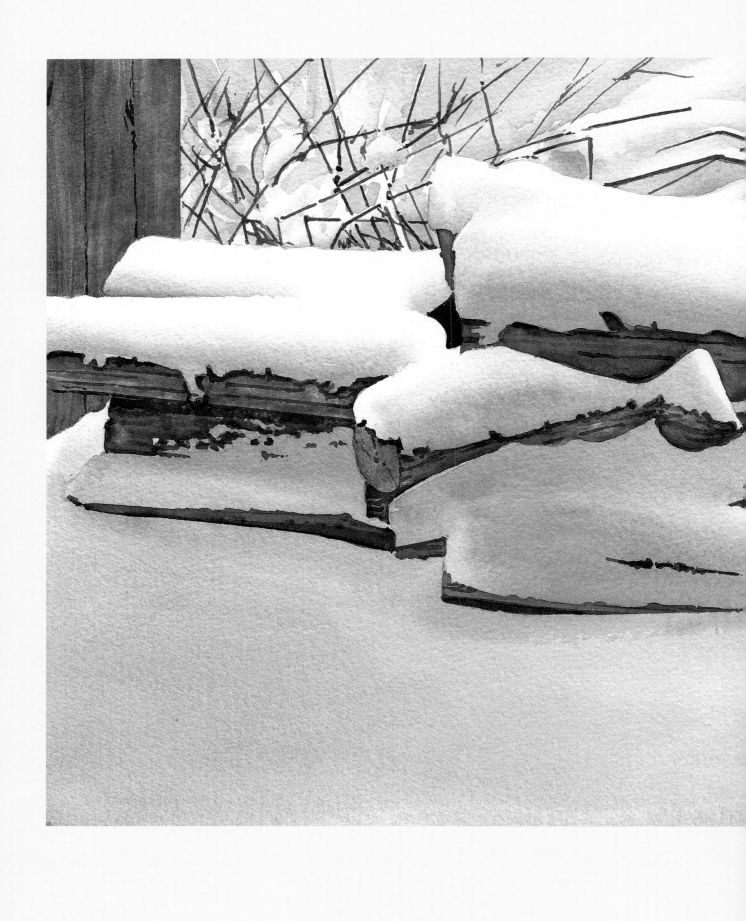

PAINTING SNOW
STEP BY STEP

Now it's time to flex your muscles a bit. In these four paintings that you will create, you'll be working with entire compositions rather than individual elements of snow. I'll be asking you to use more color and to pull into play all of the four basic watercolor techniques outlined in chapter one. I'll teach you a few new tricks along the way, and hopefully you will become more confident as you work. Remember, the only way to learn is by doing.

Fresh Snow on Firewood
14" × 20" (36cm × 51cm)
Watercolor on Arches 300-lb. (640gsm)
rough watercolor paper

Demonstration One: Concrete Bridge in Snow

This snow-covered bridge is not far from my home in Brampton, Ontario. It's unique in that they don't make this type of bridge anymore—it's solid concrete and cannot be widened. So what's the big deal about the bridge? Well, I like the way the white snow pops up on the bridge supports. Notice how the concrete becomes quite dark because the snow melts and runs down. I especially like how the graded washes suggest indents in the snow, when in fact it's just a graded wash.

Why Create a Pencil Value Study?
A pencil value study is like a blueprint—it tells you where you're going and helps you work out value before you begin to paint.

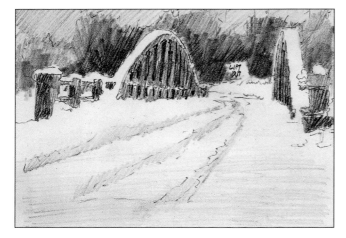

The Pencil Value Study

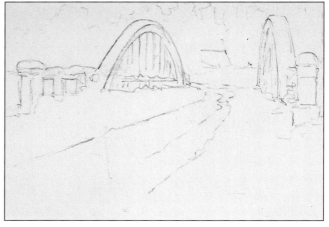

Step 1
Make a light pencil drawing to indicate the major forms and shapes.

Step 2
Mix a soft gray wash using Burnt Sienna and Ultramarine Blue. With a ½-inch (12mm) square brush, wash in the sky area right down to the road line. Paint carefully around the bridge.

Palette
Burnt Sienna
Ultramarine Blue

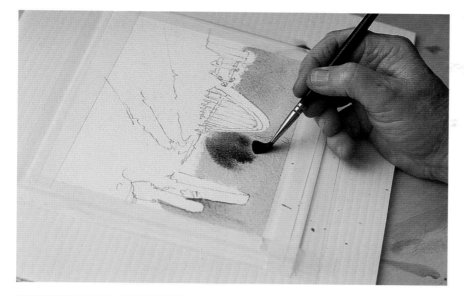

Step 3
Now mix a brown wash using Burnt Sienna and Ultramarine Blue. Flip the painting upside down, and indicate a tree line by painting around the bridge with vertical strokes.

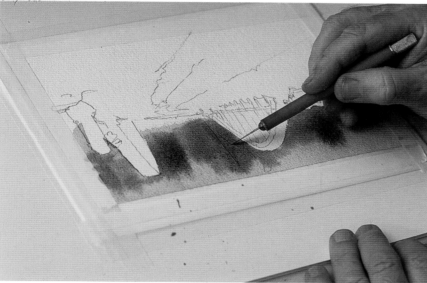

Step 4
Produce the illusion of distant trees by scoring the wet paper with a utility knife.

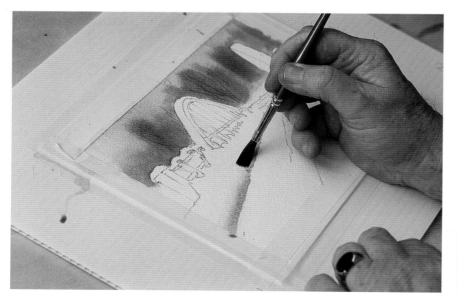

Step 5
Use the same gray wash as for the sky in step 2 and a no. 12 round brush. Beginning in the left corner, paint graded washes to suggest indents of three tire tracks.

Use Graded Washes to Imitate Soft Snow
Graded washes are perfect when you want to create the illusion of soft snow.

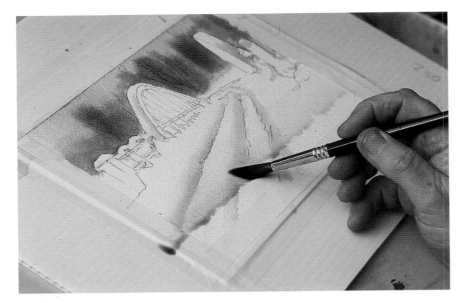

Practice on Newsprint
If ever you're not complete-ly comfortable with a par-ticular stroke, practice on newsprint first until you loosen up.

Step 6
Using the no. 12 round brush and gray wash, complete a soft graded wash across the bridge, where the snow has collected.

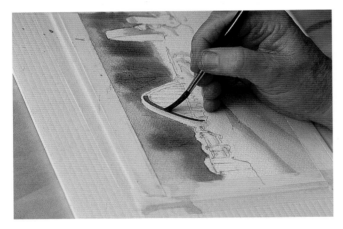

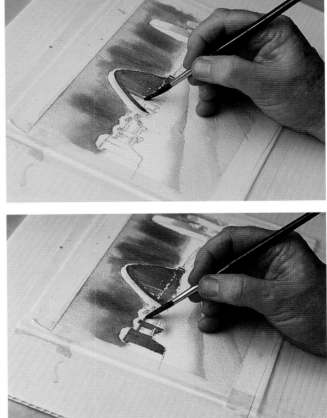

Step 7
As shown in these three photos, mix a dark brown wash using Ultramarine Blue and Burnt Sienna. With a no. 12 show card lettering brush, paint curved strokes to indicate the bridge struc-ture. Paint the supports and the cement posts using the same brush and brown wash.

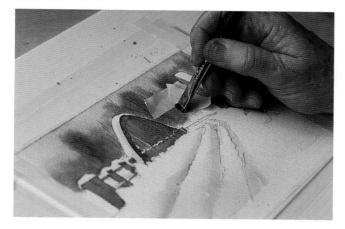

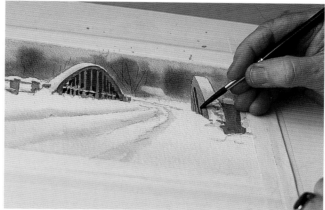

Step 8
Lay down two pieces of tape in the shape of a roof just to the right of the left-hand side of the bridge. With a scrub brush, rub the area with clean water and lift with a tissue.

Step 9
Slightly deepen the value of the brown wash used in step 3. It doesn't have to be much darker, because when you glaze, it will become dark. Paint some shadows on the upper supports.

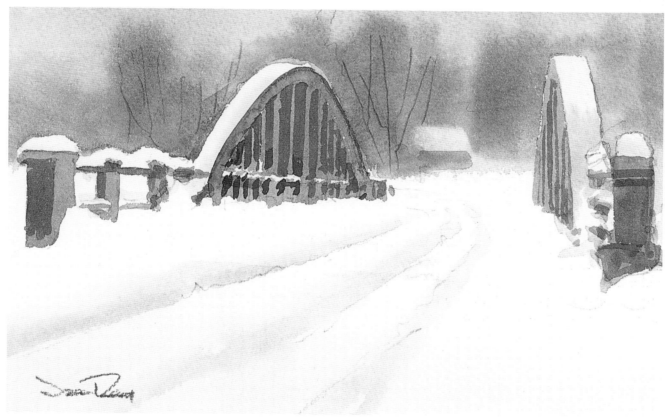

Concrete Bridge in Snow
7½" × 11" (19cm × 28cm)
Watercolor on Arches 300-lb. (640gsm) rough watercolor paper

Demonstration Two: Fresh Snow on a Cordwood Pile

I love the way fallen snow magnifies and changes the shapes of objects. For example, the woodpile in this painting is on my back porch. When I walk out back after a snowstorm, the dark color and grainy texture of the shed and the logs stand out. For paintings like this one with very soft diffused light, Cobalt Blue and Burnt Sienna make the perfect soft gray. When they dry, Cobalt Blue and Burnt Sienna create a soft, luminous feeling, making it ideal for soft shadows. Use Ultramarine Blue for stronger blues.

How to Do a Pencil Drawing
When you're doing a pencil drawing in a painting, minimize the amount of drawing you do. As you become skilled with handling the brushes, you will be able to draw with the brush. The drawing should simply indicate the elements that will be in your painting. As you develop confidence, you won't need more than a simple sketch. Be patient, it will come in time.

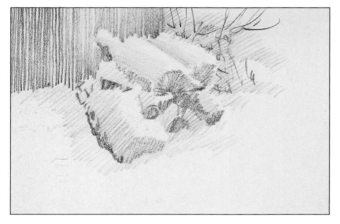

The Pencil Value Study

Step 1
Sketch pencil drawing. Be careful and spend a little time on this. If you spend a bit of time sketching, it helps when you go to put the paint down.

Step 2
Mix a soft gray wash using Cobalt Blue and Burnt Sienna. Using a no. 8 round brush, lay down a wash of clean water over the paper, moving carefully around the cordwood. Then using wet-in-wet and a 1-inch (25mm) square brush, paint the gray wash.

Palette
Burnt Sienna
Cobalt Blue
Raw Sienna
Ultramarine Blue

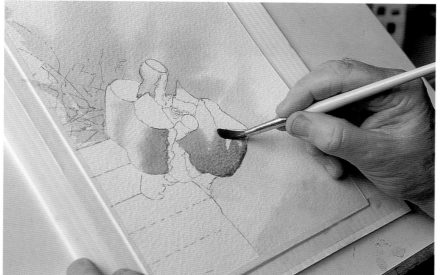

Step 3

As shown in these four photos, deepen the wash slightly and paint graded washes on the woodpile. Paint one section at a time, remembering to leave areas white for the exposed firewood. As you paint, feel free to move the paper to any angle that feels comfortable.

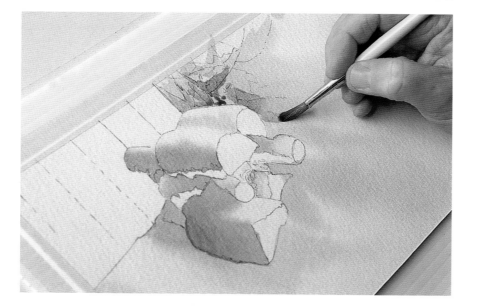

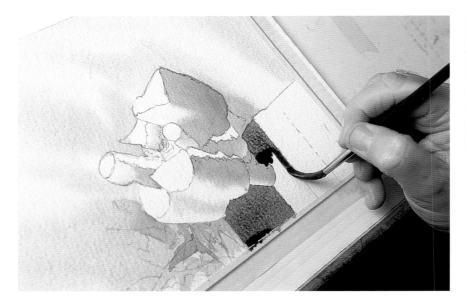

Step 4
Mix a dark brown wash with Ultramarine Blue and Burnt Sienna. Turn the painting upside down, and with the no. 12 show card lettering brush, paint the boards on the shed behind the woodpile, one at a time.

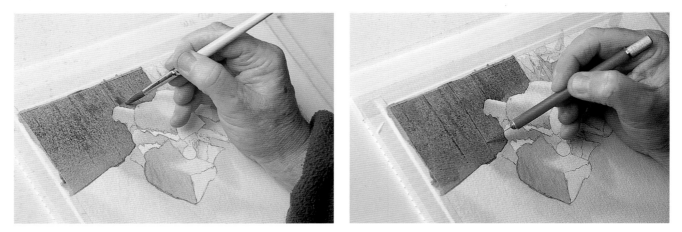

Step 5
While still wet, drop in pure Burnt Sienna and score each area with a utility knife to create the texture of wood. Let dry.

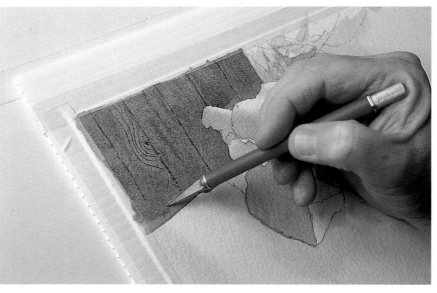

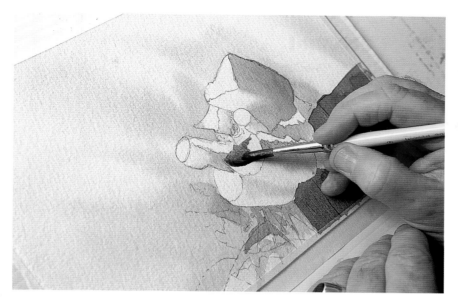

Step 6
Mix a dark brown wash from Ultramarine Blue and Burnt Sienna. With a no. 8 round brush, paint the exposed portions of the firewood.

Step 7
Drop pure Raw Sienna and Burnt Sienna onto lighter portions of the wood and again score with the knife to create wood textures. If some areas seem excessively dark, lift some of the color with a tissue.

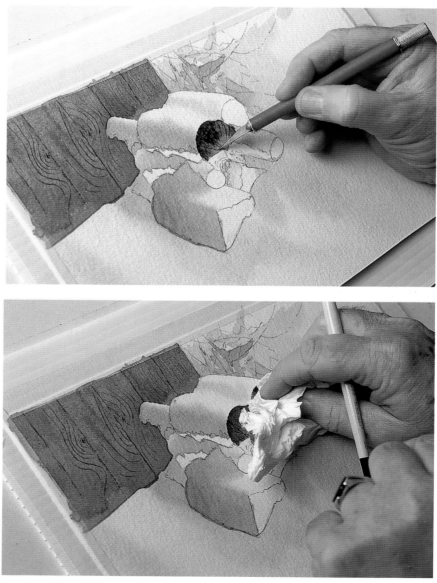

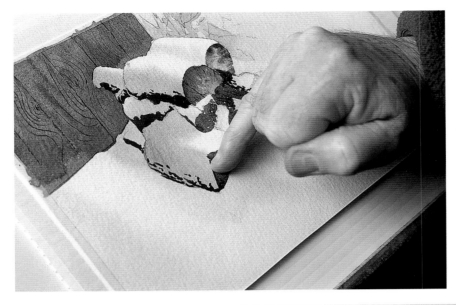

Step 8
To create a woodlike texture on the end of each log, press your baby finger into the wet paint.

Step 9
To test your drybrushing technique before applying it to the painting, practice on scrap paper. Load the ½-inch (12mm) square brush with paint and brush it along the paper until it begins to run out of paint.

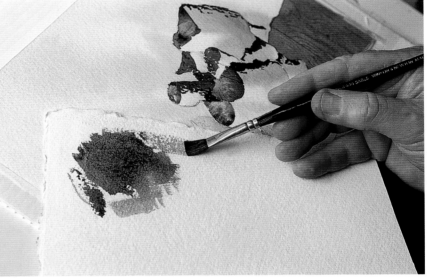

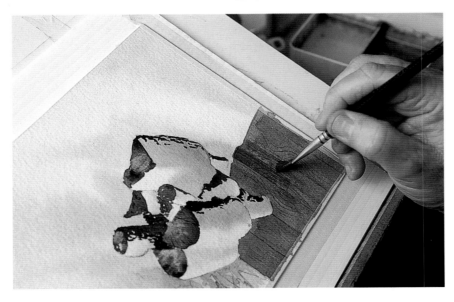

Step 10
Proceed to use drybrush to define additional texture on exposed parts of the logs and the shed. Switch to a no. 4 round brush and paint the cracks between the dark portions of the boards.

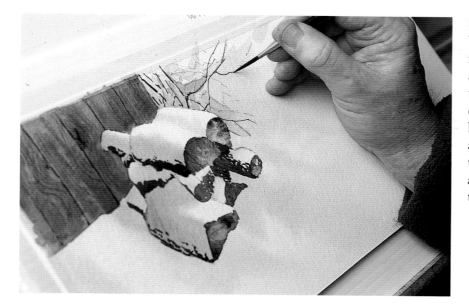

Step 11

With the same brown mix and a no. 3 rigger, paint the bushes and shrubs sticking out behind the shed. Notice how when you do this, the white on the log becomes very strong. This creates a lovely clean edge along the snow on top of the logs. Use a no. 4 round brush to tickle in texture on the wood, as well.

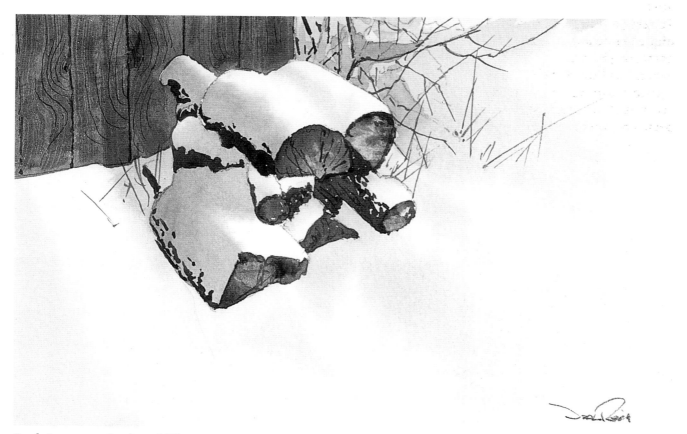

Fresh Snow on a Cordwood Pile
7½" × 11" (19cm × 28cm)
Watercolor on Arches 300-lb. (640gsm)
rough watercolor paper

Demonstration Three: Abandoned Shed in Snow

This scene is taken from the Muskokas, a chain of lakes about 150 miles north of Toronto. In the summer it's bustling with cottagers, but I prefer it in winter. I love the heavy feeling of the snow on the broken shed. Notice the strength that the stand of trees in the distance delivers to this painting. This painting is quite complex and requires careful planning up front with a pencil value study and sketch. If you find the shape of the shed too complicated, feel free to simplify some of the elements.

Palette
Burnt Sienna
Ultramarine Blue

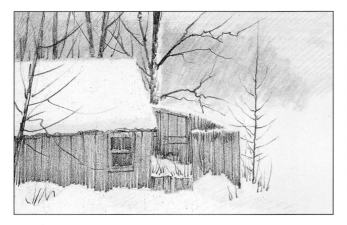

The Pencil Value Study

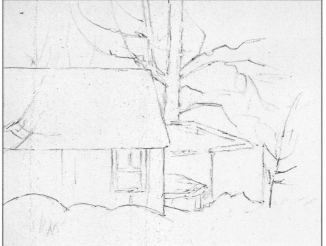

Step 1
Make a light pencil drawing to indicate the major forms and shapes.

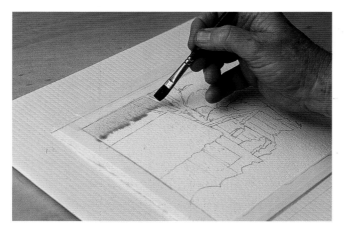

Step 2
Mix a soft gray wash from Ultramarine Blue and Burnt Sienna. Lay down the wash across the top of the paper, painting around the large tree behind the shed.

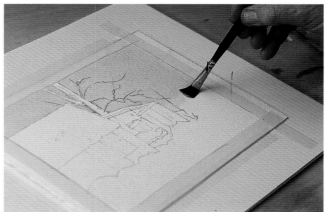

Step 3
Paint a graded wash down the right side of the shed. To create a misty effect in the background, finish with a stroke of clear water.

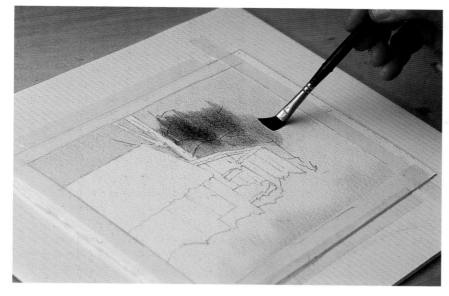

Step 4
Using a ½-inch (12mm) square brush, wet the paper just to the right and left of the shed roof. Deepen the gray wash, and paint quickly wet-in-wet over this area.

Step 5
Lift some of the paint with a tissue to create the impression of snowdrifts.

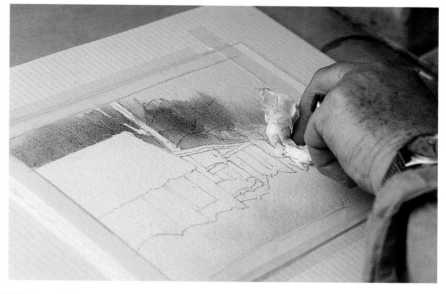

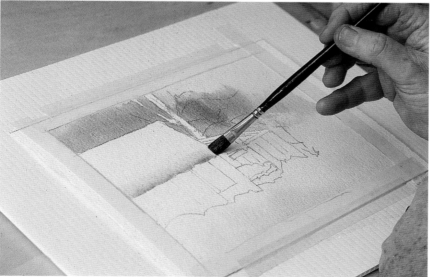

Step 6
To suggest heavy snow, use the same gray and paint a graded wash on the edge of the building and let dry.

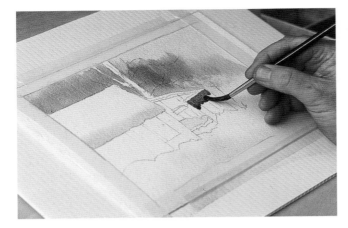

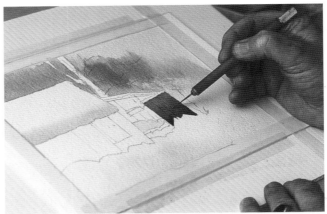

Step 7

Mix a brown wash using mostly Burnt Sienna and a touch of Ultramarine Blue. Use the no. 12 show card lettering brush to paint the boards, starting on the right side of the snow edge. Usually on a roof edge, especially in northern climates, sap runs and causes a red-yellow color. To create this effect, drop in some pure Burnt Sienna. For the rest of the boards, drop in the brown wash as you paint down.

Step 8

While still wet, score the paper with a utility knife to create texture on the boards. This will save you the trouble of having to paint a series of tiny lines with a very small brush.

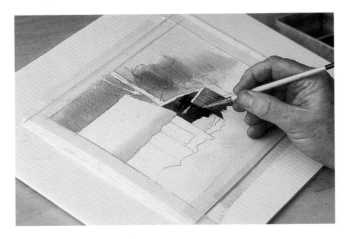

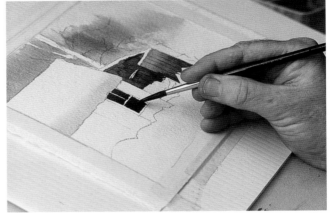

Step 9

The next step is a little tricky. With a no. 8 round brush and the same brown mix, paint carefully around the caved-in shed.

Step 10

Paint some square windows with a no. 12 show card lettering brush and the brown mix. Let dry.

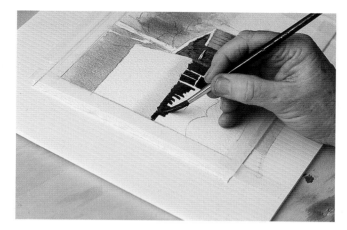

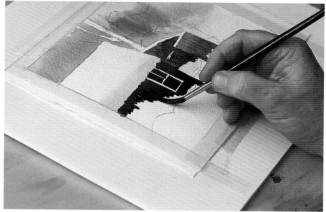

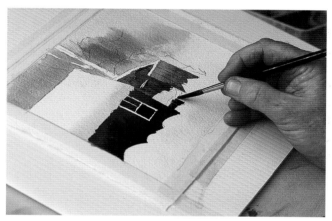

Step 11

As shown in these three photos, using the same brown mix and brush, paint the boards on the side of the shed, leaving the impression of snowdrifts at the foot of the shed. Paint the exposed part of the broken doorway in front of the cabin on the right-hand side.

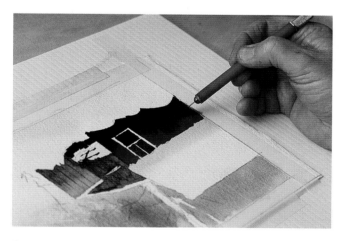

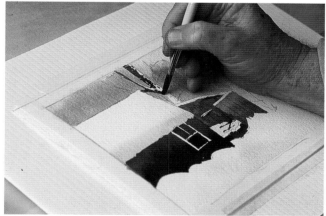

Step 12

While wet, score the boards with a utility knife. Let dry completely.

Step 13

With the same brown mix and a no. 8 round brush, paint the tree, remembering to leave white for snow on the branches. At this point you are really drawing in with the brush, so make things sketchy. The size of the round brush is really not as important as the pressure you apply.

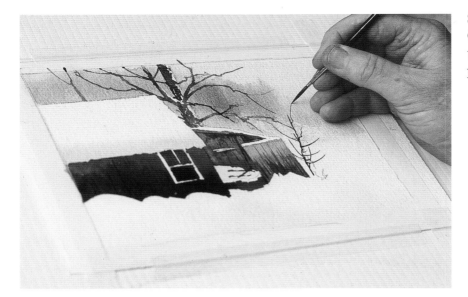

Step 14
Grab your no. 3 rigger and, using the same brown mix, paint the sapling on the right.

Step 15
Paint the trim around the exposed window frame.

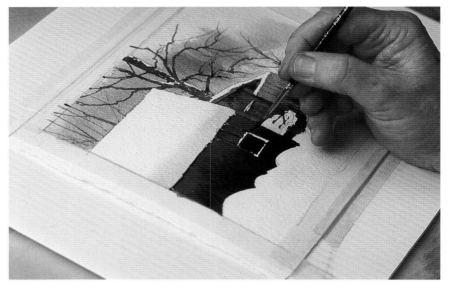

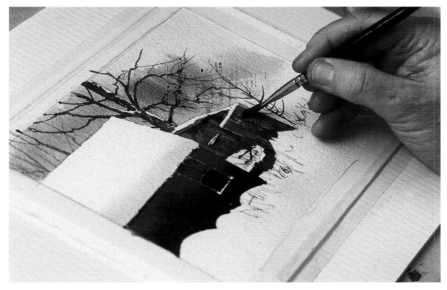

Step 16
Using a ½-inch (12mm) square brush and the brown mix, dry-brush over the boards on the shed to suggest texture.

Step 17

Using a no. 3 rigger and a light brown mix of Ultramarine Blue and Burnt Sienna, paint some exposed weeds and grasses in the foreground and exposed branches and leaves over the white roof.

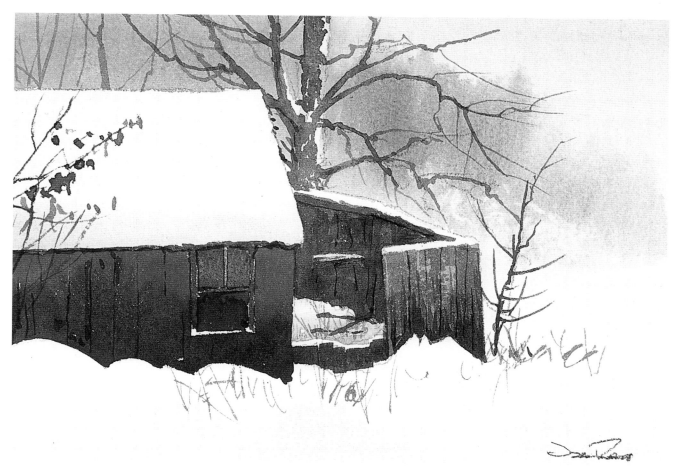

Abandoned Shed in Snow
7½" × 11" (19cm × 28cm)
Watercolor on Winsor & Newton 260-lb. (550gsm) watercolor paper

Demonstration Four: Sunlit Forest in Deep Snow

Oh, the joy of grabbing a pair of snowshoes and trekking into the woods on a bright sunny day after a big snowstorm. Deep snow and strong sunlight just drive me crazy. Long ago I discovered the best way to paint depth to a forest was to glaze nonstaining pigments. In this painting, each glaze of blue reduced the value of the trees, adding a new dimension. In the foreground you'll notice some hollows (these are stumps, weeds and branches hidden under the snow). You'll also notice that when the shadows of some trees fall across trees in the foreground, they reduce the amount of white left on the paper. The result is the impression of both diffused light and hard-edged bright sunlight.

The Pencil Value Study

Palette
Aureolin Yellow
Burnt Sienna
Cobalt Blue
Rose Madder Genuine
Ultramarine Blue
Viridian Green

Step 1
Make a light pencil drawing to indicate the major forms and shapes.

Step 2
Mix a blue wash from Rose Madder Genuine, Aureolin Yellow and Cobalt Blue with emphasis on the blue. Using clear water, wet the paper in the foreground, leaving white areas as indicated. Paint the blue wash wet-in-wet. Let dry.

Step 3
With the same blue wash and a no. 12 round brush, paint carefully around the large snow-covered trees and branches in the foreground.

Step 4
Make a graded wash using clean water to soften the edge of the shadow.

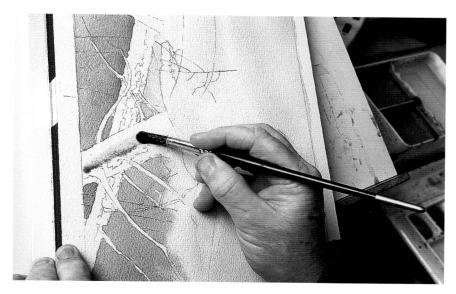

Step 5
Turn the paper on its side and hold at a 15° angle. On the main trunk, paint a soft graded wash. Start with clean water and then switch to the blue wash.

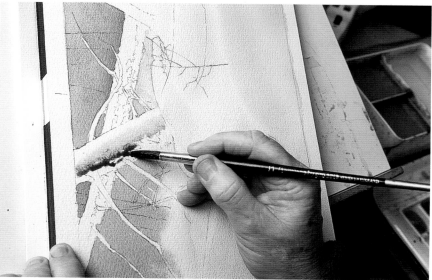

Step 6
Deepen the blue wash, and while the paper is still wet, paint the snow closest to the exposed bark. Let dry, and then glaze over the area around the distant trees.

Step 7

As shown in these two photos, mix a forest green wash from Viridian Green, Burnt Sienna and Ultramarine Blue. While the paper is still wet from the previous wash, paint wet-in-wet to create patterns of distant fir trees. Let dry.

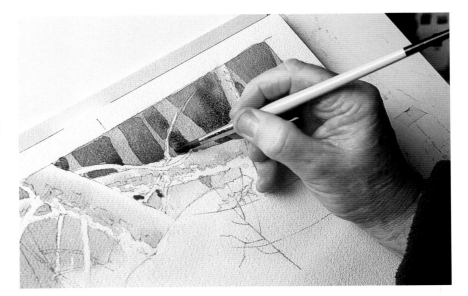

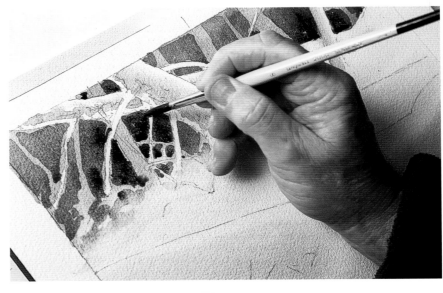

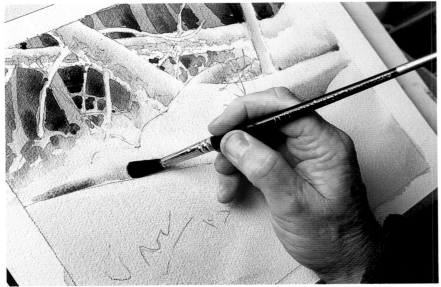

Step 8

Paint a second blue graded wash on the snowdrift in the upper left. Notice how as the white paper is reduced, the power of the remaining white paper increases.

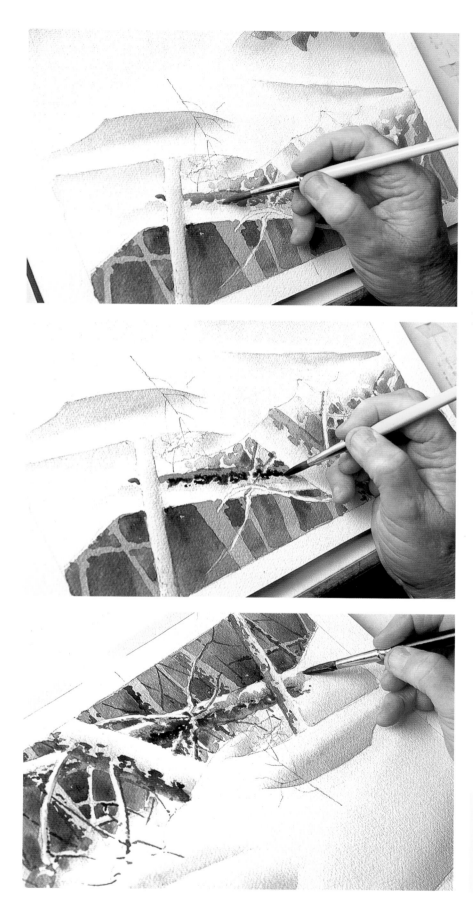

Step 9

As you see in this sequence of three photos, turn the paper upside down, and with a no. 8 round brush, paint pure Burnt Sienna along the bottom edge of the bare trunk. Quickly add a dark brown graded wash that begins with mostly Burnt Sienna and Ultramarine Blue and gradates to mostly Ultramarine Blue and Burnt Sienna. The Burnt Sienna represents the reflected light from the sunlit snow. Repeat until all exposed bark in the foreground has been painted, as well as that on the distant trees.

Graded Washes Create Roundness
A graded wash is a great technique for creating the impression of roundness.

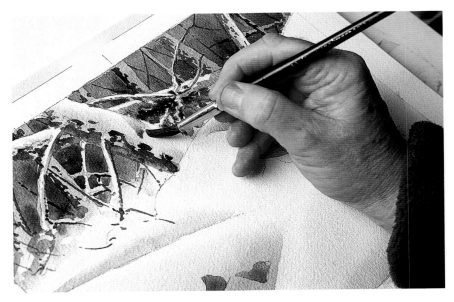

Step 10

As shown in the photo sequence on this page and the next, using the same blue wash of Rose Madder Genuine, Aureolin Yellow and Cobalt Blue as for the snow shadows in the foreground and a no. 12 show card lettering brush, paint long flat shadow patterns of tree trunks and branches in the snow.

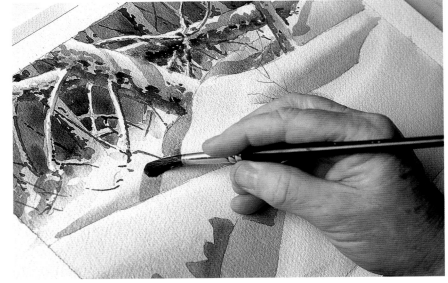

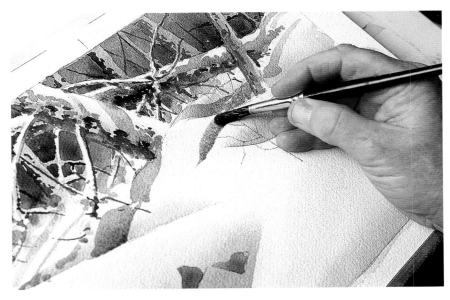

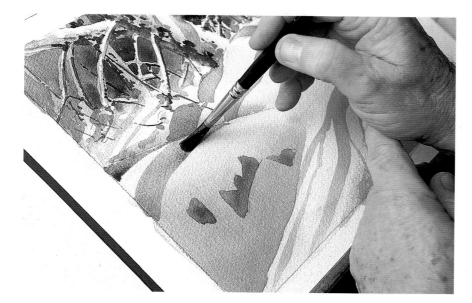

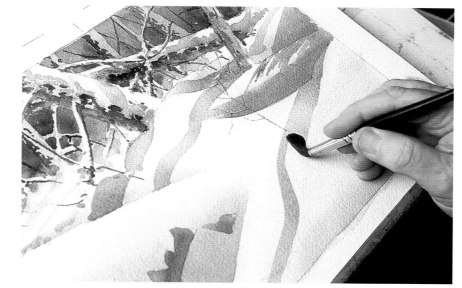

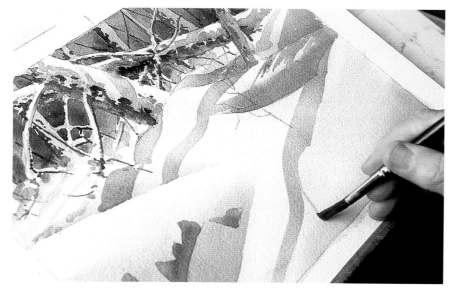

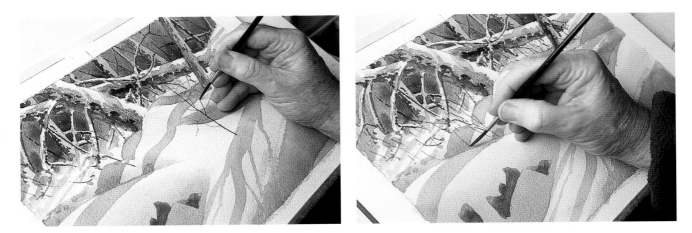

Step 11
Mix a dark brown wash from Ultramarine Blue and Burnt Sienna.
Using a no. 3 rigger, paint a few saplings with thin branches.

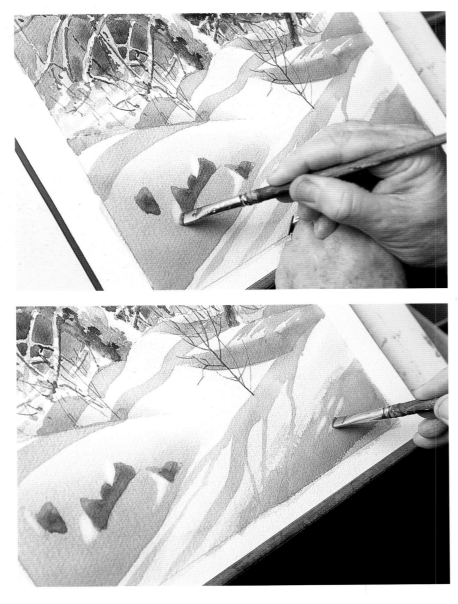

Step 12
Scrub out white highlights in
the snowbank.

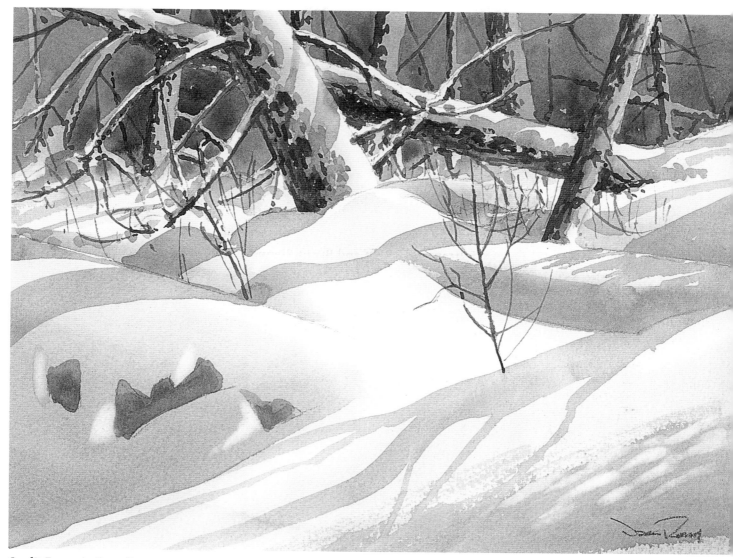

Sunlit Forest in Deep Snow
9" × 12" (23cm × 30cm)
Watercolor on Winsor & Newton
260-lb. (550gsm) rough watercolor paper

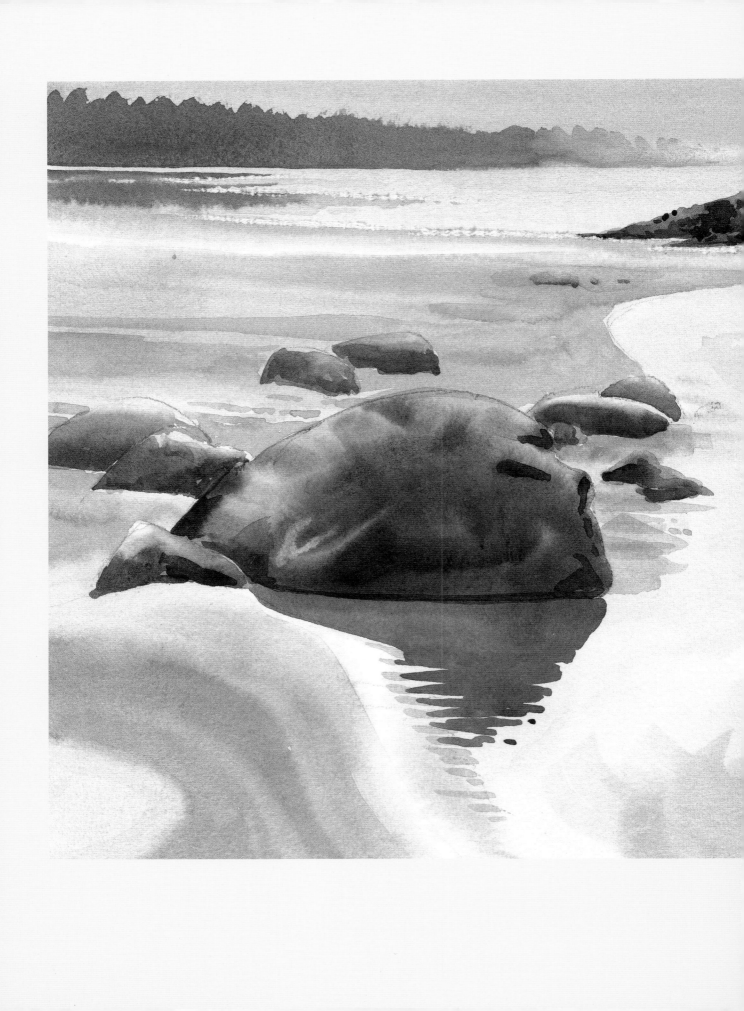

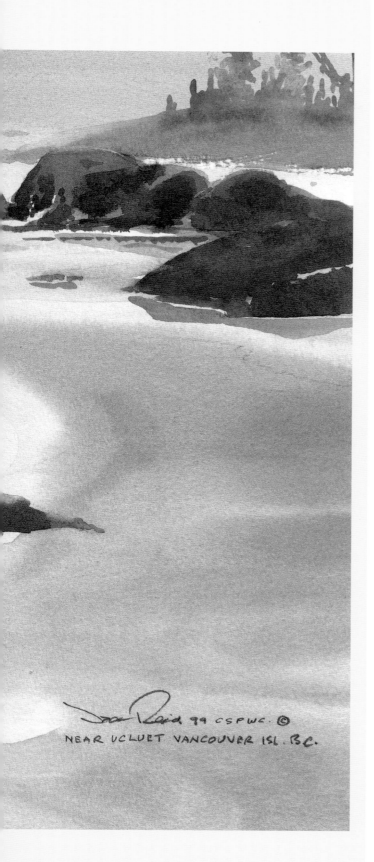

Near Ucluet Vancouver Isl. B.C.

4

WATER

Watch water and you'll notice it's always changing—one minute a mountain stream may be flowing smoothly, the next it's a roaring iridescent white foam crashing over rocks, only to return once again a few yards away into its former soft, serene flow. What I find most exciting about water is its transparent nature. I can't think of a better medium to paint it in than transparent watercolor pigments!

As an artist, there's really only so much I can express through words about water. Words aren't the way I prefer to express what I feel. But through paint—now that's a very personal thing, and watercolors allow me to express and share those feelings with others. The greatest challenge you'll face as an artist is in translating what you see and feel into colorful nondimensional visual images. It's difficult, but not impossible.

In this chapter, I'll show you a variety of water-related elements and how to paint them using only a few pigments. At any time, if an exercise seems too difficult, just simplify it to your level.

I trust my philosophy hasn't intimidated you. Just keep in mind that successful painting is based on inspiration followed by perspiration. Now let's paint water!

Near Ucluet, Vancouver Island, British Columbia
11" × 15" (28cm × 38cm)
Watercolor on Winsor & Newton 260-lb. (550gsm)
rough watercolor paper

Painting Sunlight on Water

Late summer sunlight sparkling on water is, to me, one of the most fascinating and challenging subjects. The best way to create this type of illusion is with graded washes and drybrush. The graded wash suggests the central highlight as it turns gradually to shadow and the drybrush suggests the sparkle on the water.

Palette
Burnt Sienna
Raw Sienna
Ultramarine Blue
Viridian Green

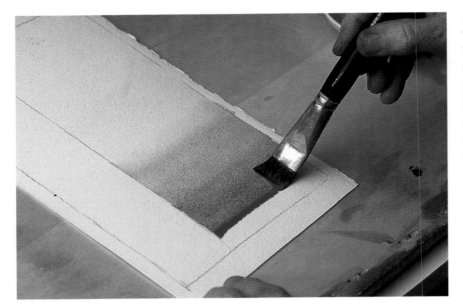

Step 1
Tip your paper on its side, and beginning about midway down the paper, paint a graded wash using a 1-inch (25mm) square brush. Start with clean water and add Ultramarine Blue, carrying the wash down to the bottom of the page. Turn the paper around and paint the opposite side also using a graded wash.

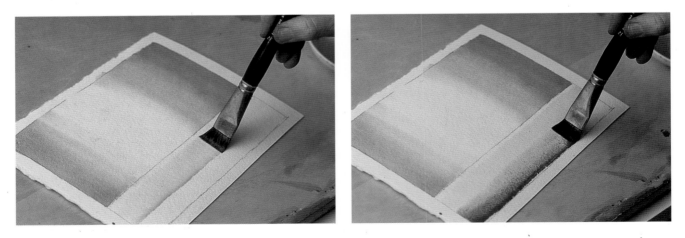

Step 2
Now paint a graded wash that begins with Raw Sienna and switches to Burnt Sienna and Ultramarine Blue. Let dry.

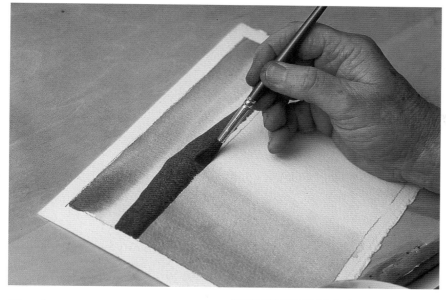

Step 3
Mix a grungy-green wash from Viridian Green, Burnt Sienna and Ultramarine Blue. Now paint the silhouette of the distant headland.

Step 4
Render the tree line and building in the right foreground. If required, add water to reduce the value.

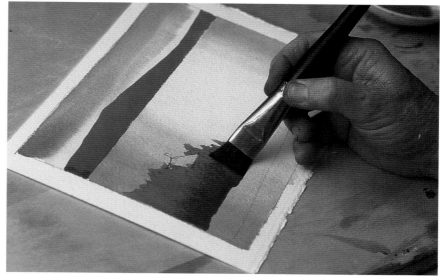

Step 5
Complete the picture by dry-brushing a mixture of Ultramarine Blue and Burnt Sienna across the water to suggest sparkles. Drag a 1-inch (25mm) square brush on an angle across the water area on the paper.

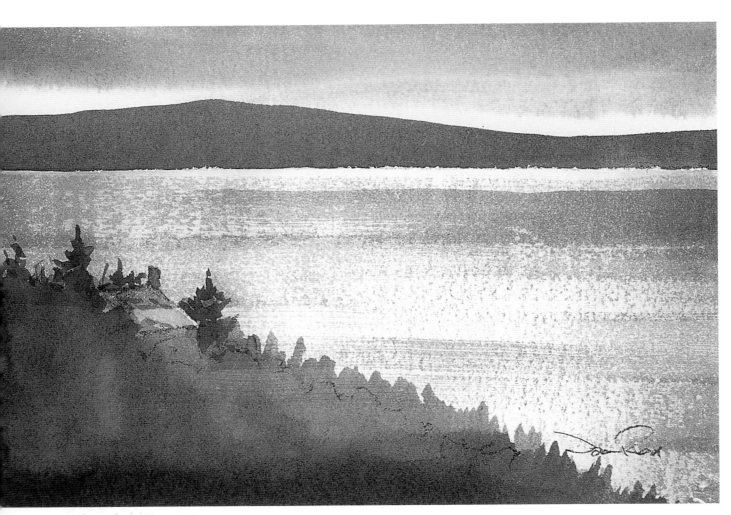

Light Path on Water
7½" × 11" (19cm × 28cm)
Watercolor on Arches 300-lb. (640gsm) rough watercolor paper

Painting Still Water

This painting is more about water than snow. Notice how the edges of the tree and snow reflections on the water are hard.

Step 1

Mix a blue-gray from Burnt Sienna and Ultramarine Blue. Using a no. 8 round brush, begin a series of graded washes beginning in the upper left. Start with clean water and add blue-gray gradually. Repeat graded washes along the upper right side of the pond, the islands on the left, and the sweep of shadow along the edge of the snow. If the value seems too dark, simply lift with a tissue. To create hard-edged reflections, paint flat washes with a stronger value of the same blue-gray wash with a round brush. Let dry.

Mix More Paint Than You Need

There's nothing worse than running out of pigment before you've finished painting an area, so always mix a larger wash than you think you'll need. It's virtually impossible to remix a wash exactly.

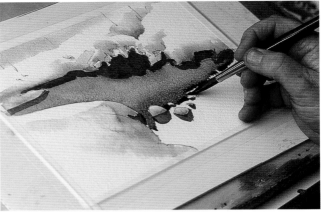

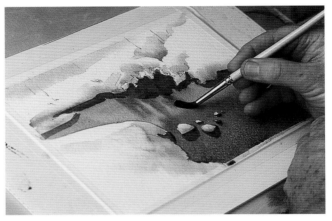

Step 2

Now mix a medium-value brown-gray wash using Ultramarine Blue and Burnt Sienna. Paint a flat wash across the pond as shown. While still wet, use a no. 8 round brush and drop pure Burnt Sienna, as well as Burnt Sienna mixed with Ultramarine Blue. Let dry.

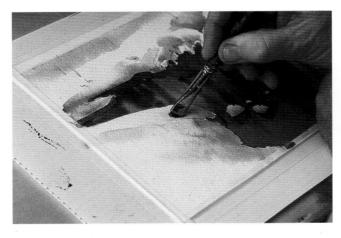

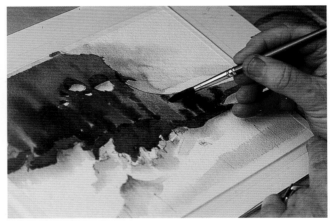

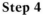

Step 3

Use a scrub brush to lift highlights on the snow in the lower left.

Step 4

Flip the paper upside down and with a no. 8 round brush and the same brown-gray wash used for the pond in step 2, paint more reflections.

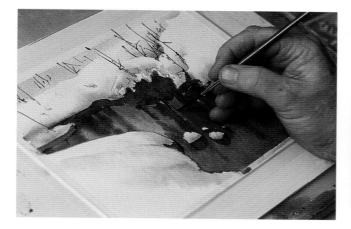
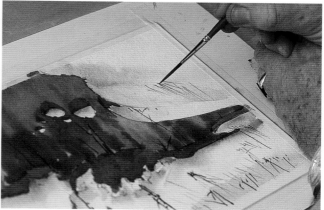

Step 5
Using the same brown-gray wash and a no. 3 rigger, paint vegetation around the pond. Then paint reflections on the pond.

Step 6
Mix a wash from Raw Sienna, Burnt Sienna and Ultramarine Blue. Turn the painting so you're comfortable. With a no. 3 rigger, paint grass in the background and in the foreground snowbank.

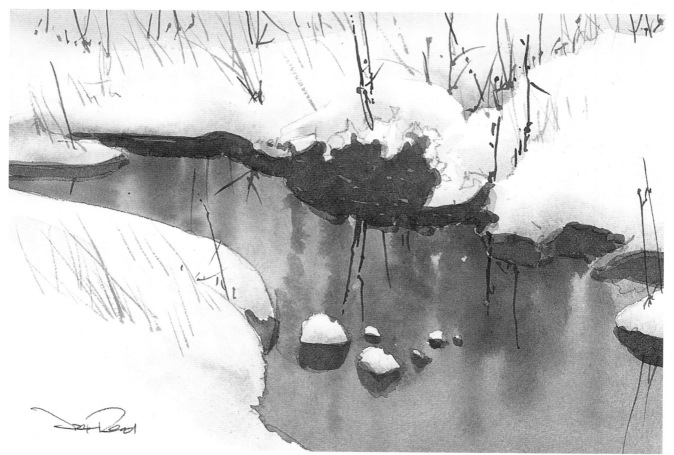

Reflections in a Winter Pond
7½" × 11" (19cm × 28cm)
Watercolor on Arches 300-lb. (640gsm) watercolor paper

Painting Breaking Surf

The key aspect to completing a good seascape is to capture the mood. In this painting I've portrayed the tremendous force of an enormous wave breaking close to the shoreline. To make it work, leave lots of white to represent foam and contrast it with hard rocks.

Palette
Aureolin Yellow
Burnt Sienna
Cobalt Blue
Ultramarine Blue
Viridian Green

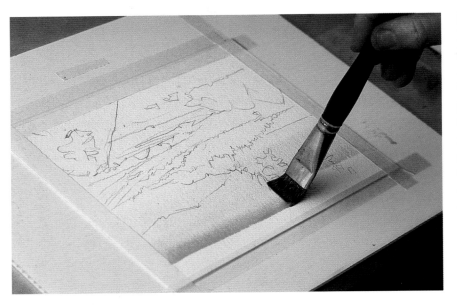

Step 1
Flip the paper upside down. Begin with a graded wash of Aureolin Yellow, then paint Cobalt Blue to the top of the paper, wiping off the beaded edge. Let dry. Mix a gray wash from Cobalt Blue and Burnt Sienna and, using a graded wash, paint the distant mountains. Reduce the value where they meet the sea.

Step 2
Mix a wash of Cobalt Blue and Viridian Green. Using a graded wash, paint the fold of the wave. Reduce the wash up toward the foam, making sure you don't lose the white on the upper edge of the breaker. Then let dry.

Step 3

Render in the water against the headland, painting carefully around the wave. Make sure to leave lots of white. Deepen the Cobalt Blue and Viridian Green wash and paint the edge of the big breaker on the right. As you reach the bottom edge of that wash, create a bit of haze by lifting color with a tissue.

Step 4

Mix a brown wash from Burnt Sienna and Ultramarine Blue. Paint the headland behind the crashing wave. Turning the paper so you're comfortable, add Viridian Green so the wash becomes a dark green-black. Paint the rocks and evergreen trees.

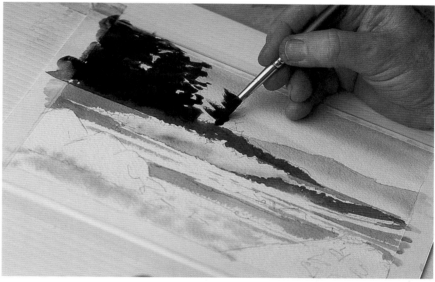

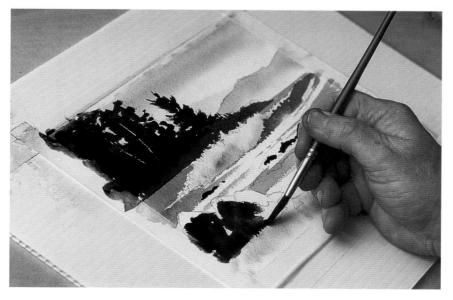

Step 5

Mix a brown wash from Burnt Sienna and Ultramarine Blue. Using a 1-inch (25mm) square brush, paint the rocks just before the wave and in the foreground. Paint quickly. Let dry.

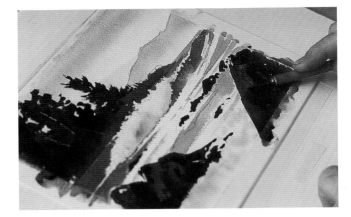
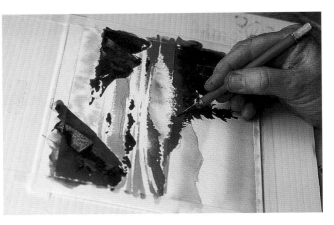

Step 6
As shown in these three photos, use a utility knife to add in the finishing touches. Lift out suggestions of tree trunks along the headland, and with the same knife placed on its edge, scrape some highlights on the rocks in the foreground.

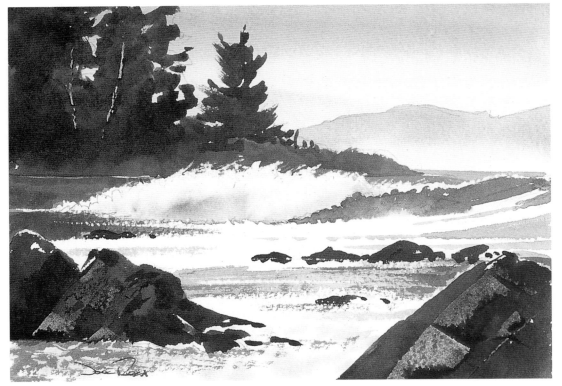

Breaking Surf, Rocks and Mountains
7½" × 11" (19cm × 28cm)
Watercolor on Arches 300-lb. (640gsm) rough watercolor paper

Painting Rocks in Water

Students have asked me hundreds, if not thousands, of times how to paint rocks partially submerged in water. The answer is to glaze with nonstaining pigments only. This is somewhat tricky, so if you're feeling timid, practice with just a few rocks at first.

Palette
Burnt Sienna
Cobalt Blue
Raw Sienna
Ultramarine Blue

Step 1
As shown in these two photos, start by painting the largest rock first. Beginning with clear water, paint a graded wash of mostly Burnt Sienna and Raw Sienna, with a touch of Ultramarine Blue.

Step 2

To paint the other rocks, mix various values of browns and grays from Ultramarine Blue, Burnt Sienna and Raw Sienna. Use a no. 8 round brush for the large rocks and a no. 4 round for the smaller rocks and repeat the process of graded washes. Remember these three colors are nonstaining, so if color from one rock runs accidentally into another, simply wet with clean water, rub with the scrub brush and lift with a tissue. When done, let dry.

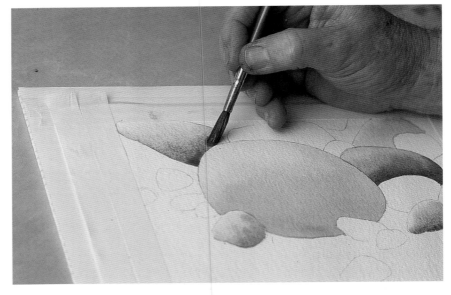

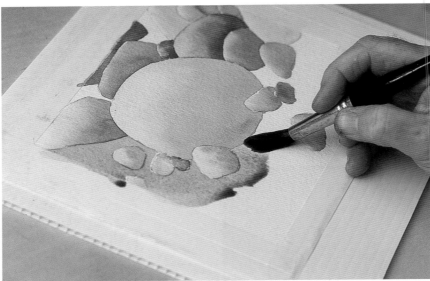

Step 3

For the sand bottom, mix a dark brown using Burnt Sienna and Ultramarine Blue and paint around the rock areas.

Step 4

Pencil in a faint line to indicate where the waterline will be.

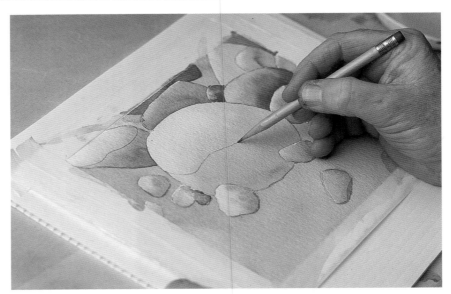

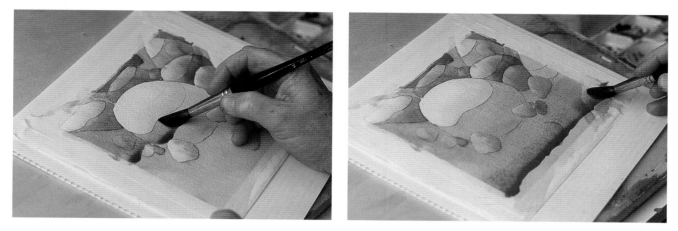

Step 5

Mix a soft blue-gray wash from Cobalt Blue and Burnt Sienna. The water is transparent and so are the pigments, so glaze over everything but some of the rock surfaces using a no. 8 round brush. This is a little bit tricky and you have to move somewhat quickly.

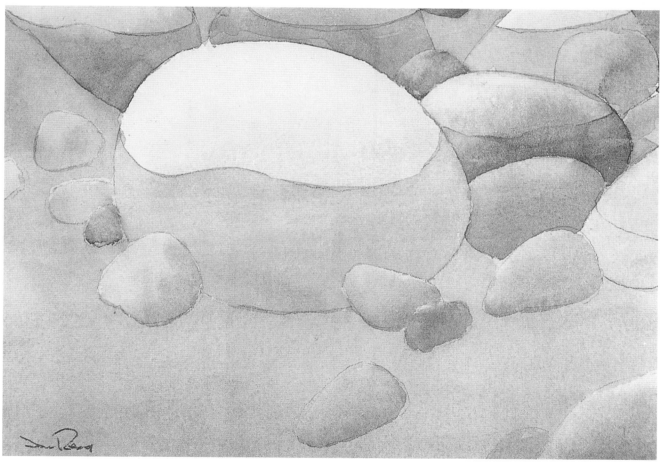

Partially Submerged Rocks in Water
7½" × 11" (19cm × 28cm)
Watercolor on Winsor & Newton 260-lb. (550gsm) watercolor paper

Painting Waterfalls

Waterfalls seem to be the most popular subject students want to paint. Painting huge rocks is important to create the illusion of foam and mist and crashing water. Again, we'll use graded washes and leave lots of white paper. And be careful not to lose the whites in the waterfall!

Palette
Aureolin Yellow
Burnt Sienna
Cobalt Blue
Rose Madder Genuine
Ultramarine Blue
Viridian Green

Step 1
Moisten the paper with clear water. Using wet-in-wet, paint a wash of Cobalt Blue.

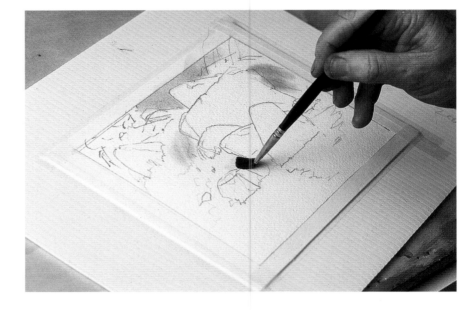

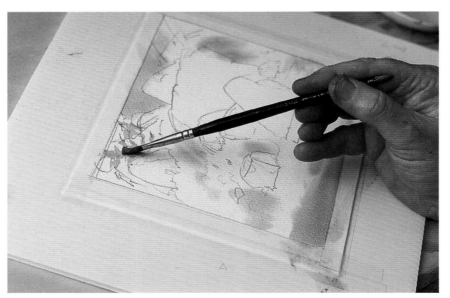

Step 2
With a wash of Aureolin Yellow, paint the lit areas of the trees in the upper left-hand side.

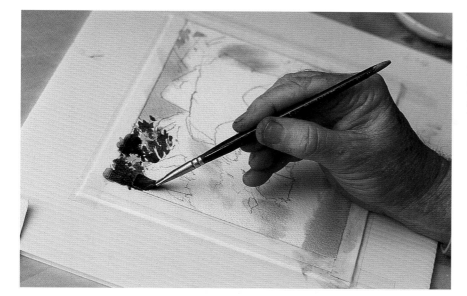

Step 3
Mix a strong value wash of Viridian Green and Ultramarine Blue darkened with a touch of Burnt Sienna. Paint the dark portions of the tree line.

Step 4
Mix a wash from Burnt Sienna and Ultramarine Blue. Using a ½-inch (12mm) square brush, start at the top of the center rock and paint the large flat rock shapes with quick strokes. Drop a touch of Rose Madder Genuine to create a pink cast.

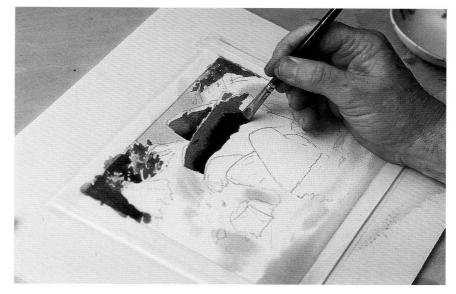

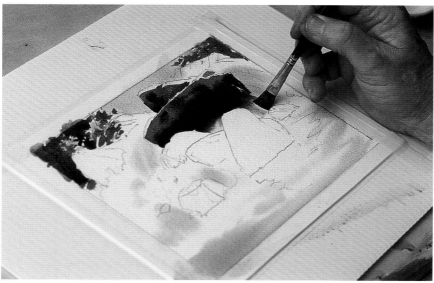

Step 5
Using wet-in-wet, gradually add a mix of Ultramarine Blue and Burnt Sienna to the rock's front.

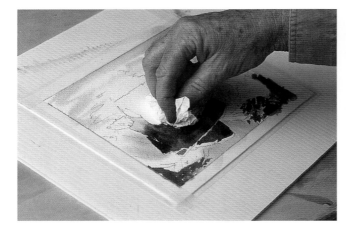

Step 6
Lift the excess with a tissue to reduce the value and create the illusion of foam around the rocks.

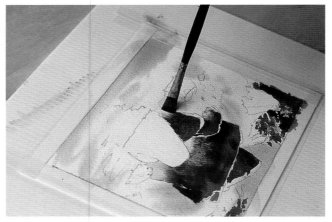

Step 7
Using a mix of Viridian Green and Ultramarine Blue with a touch of Burnt Sienna, paint the two large rocks in the foreground. Paint the rocks on top of the waterfall with the same mix but in different values.

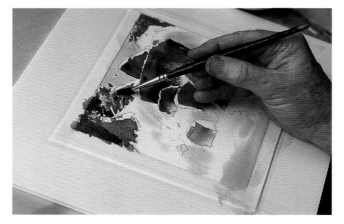

Step 8
Paint the rocks on either side of the waterfall using the same colors but in a much lighter value. Remember to paint graded washes at the bottom of all rocks.

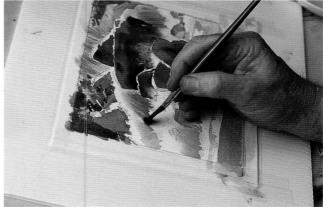

Step 9
Mix a wash of Cobalt Blue with a touch of Viridian Green and create some graded washes around the rocks and into the foam. Begin with clean water to suggest the gradation of the falls, ending with a hard edge. Repeat for the rocks in the foreground, drybrushing at the base.

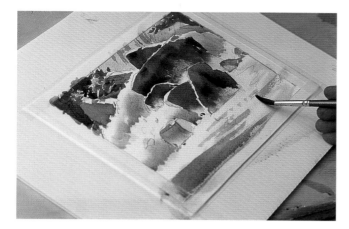 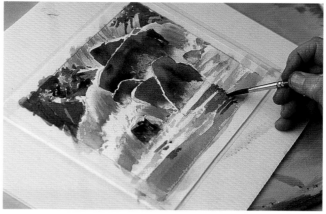

Step 10
Using Cobalt Blue, drybrush over portions of the water in the foreground, as well as the water reflections.

Step 11
With the same pigments used for the rocks, use wet-in-wet technique and drop in the reflections of the rocks in the foreground as shown in these two photos.

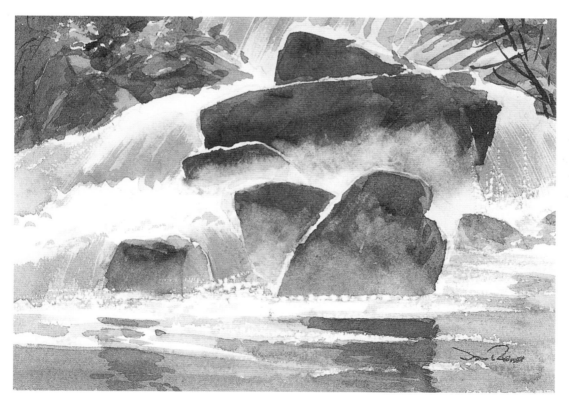

Waterfall and Rocks
7" × 10"
(18cm × 25cm)
Watercolor on Fabriano 300-lb. (640gsm) rough watercolor paper

Painting Mist

This painting is a perfect demonstration of how graded washes can create the illusion of morning mist. The whole idea here is to paint recessions of color. Notice how every element of this painting was painted using graded washes.

Palette
Burnt Sienna
Cobalt Blue
Raw Sienna
Ultramarine Blue
Viridian Green

Step 1
Using a 1-inch (25mm) square brush, wash the entire surface with clean water. Paint a graded wash to the bottom of the paper, adding Raw Sienna, and let dry.

Step 2
Turn the paper upside down and paint a flat wash of Cobalt Blue across the sky area.

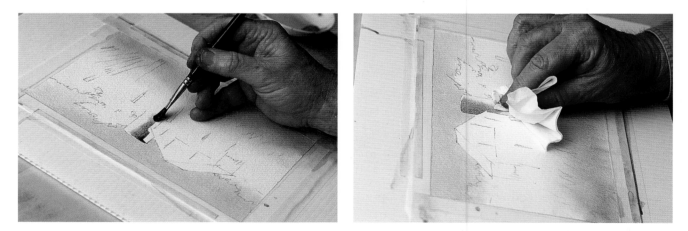

Step 3
Mix a light-value brown wash from Burnt Sienna and Cobalt Blue and paint a graded wash on the silo. Begin with the brown wash and add water gradually. If the wash seems too dark, simply lift it with tissue.

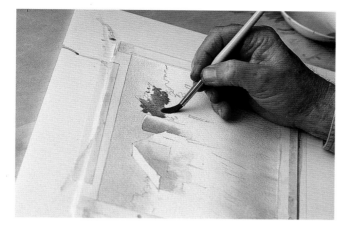

Step 4

With the same mix, paint a graded wash on the barn. To suggest the sun hitting the side of the barn, paint it light in value. Using a wash of Burnt Sienna, paint the maple tree beside the silo, leaving it somewhat lighter on the right-hand side. Then, mix a green wash from Cobalt Blue and Raw Sienna, with a touch of Viridian Green, and drop it in wet-in-wet. Lift out the bottom part of the tree with a tissue.

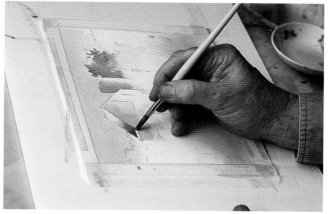

Step 5

Paint a graded wash on the barn roof, starting with clear water to which you'll add Raw Sienna and then Burnt Sienna. These two colors also suggest rust on the roof.

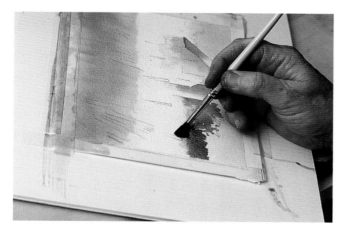

Step 6

Mix a wash from Cobalt Blue and Raw Sienna, with a touch of Burnt Sienna, and paint in the distant tree line. The left side has color, but the right is blue-gray to suggest shadow. Then turn the picture upside down and paint clear water along the bottom.

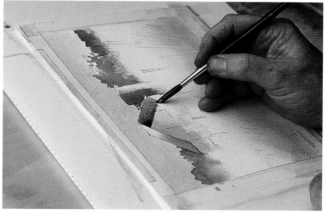

Step 7

Mix Ultramarine Blue and Burnt Sienna into a deep-value blue-gray wash. Paint the edge of the shadow on the silo and the barn and let dry.

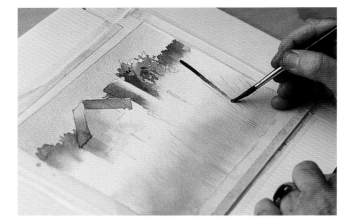
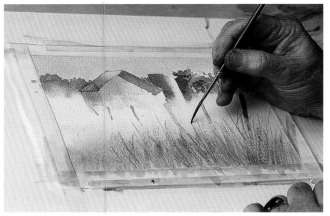

Step 8

Deepen the wash by adding a touch of Burnt Sienna. Paint a graded wash for the fence post on the right, using a no. 12 show card lettering brush. Apply just the right amount of pressure to get the thickness you want. To create the illusion of the posts receding into the distance, decrease the value by adding water to the wash as you do each post.

Step 9

Mix Burnt Sienna, Raw Sienna and Cobalt Blue and, using a no. 3 rigger, paint the grass. Then use a ½-inch (12mm) square brush and drybrush the same mix upwards over the grass area. Be careful not to color the mist area.

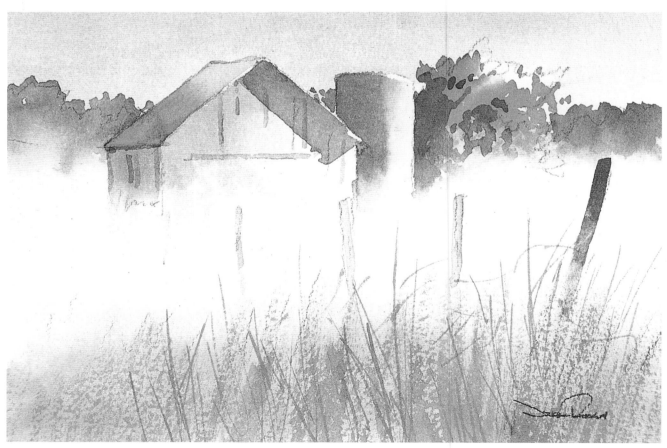

Barn and Fence in Mist
7½" × 11" (19cm × 28cm)
Watercolor on Arches 300-lb. (640gsm) rough watercolor paper

Painting Puddles

After it rains, dips in a gravel road hold wonderful puddles. I love painting puddles (the smooth water surface reflects the light and surroundings perfectly). In this exercise I've contrasted fall colors with the dull foreground colors so that the puddle becomes the focal point.

Palette
Aureolin Yellow
Burnt Sienna
Cobalt Blue
Rose Madder Genuine
Ultramarine Blue
Viridian Green

Step 1

Mix a gray wash from Burnt Sienna and Ultramarine Blue. Using a no. 8 round brush, paint a flat wash down and around the puddle to the bottom of the page. As you near the bottom, darken the value somewhat by adding a touch of Ultramarine Blue. Be sure to lift the bead of wet color that forms along the bottom edge.

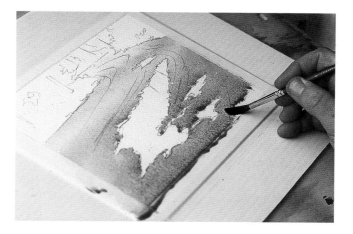

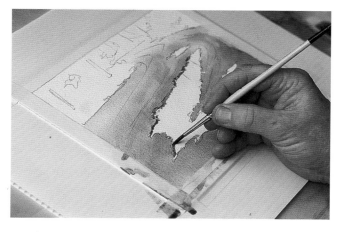

Step 2

With a no. 4 or 8 round brush, paint a very thin line of Cobalt Blue along the upper edge of the puddle. Cobalt Blue is perfect for this because it reflects light well.

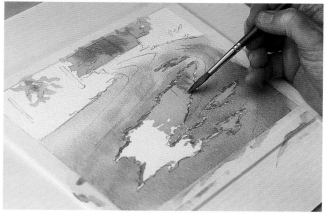

Step 3

Mix a luminescent orange wash using Aureolin Yellow with a touch of Rose Madder Genuine. Paint along the top left, where light will be seen through the trees; paint the reflection of this light in the puddle. Using wet-in-wet, break up the light and its reflection by dropping in a touch of Rose Madder Genuine.

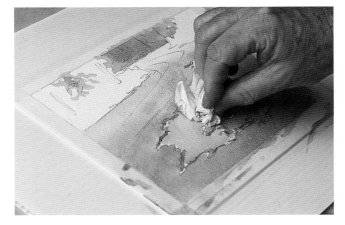

Step 4
Carry the orange wash to the bottom of the puddle. If the orange looks too strong, simply lift out the excess color with a tissue.

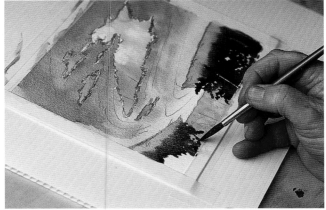

Step 5
Mix Aureolin Yellow and Burnt Sienna with a touch of Ultramarine Blue. Turn the painting upside down and paint the grasses in the upper left-hand side of the picture. Mix a strong-value grungy-green wash from Burnt Sienna, Ultramarine Blue and Viridian Green. Paint the line of trees on the left-hand side. Make sure you leave some of the glowing sky showing through the trees.

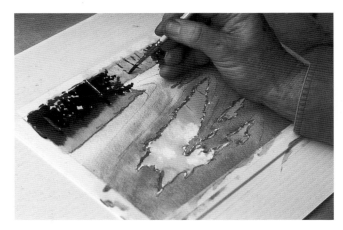

Step 6
Mix a brown wash from Burnt Sienna and Ultramarine Blue and paint some of the tree trunks in the background.

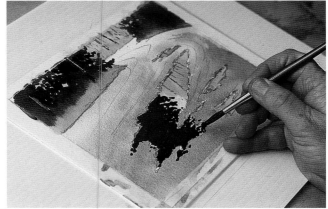

Step 7
Deepen the grungy-green mix and paint tree reflections in the puddle. Paint to the edge of the puddle, but be careful not to overlap with the Cobalt Blue. Remember to paint the reflections of the trees on the right, as well.

Step 8

Mix a soft gray wash from Cobalt Blue and Burnt Sienna. Paint a stroke across the upper portion of the road to suggest shadows from the tree line. Continue to the bottom of the paper, leaving some white patterns between the ribbons of shadow.

Step 9

Mix a dark brown wash from Ultramarine Blue and Burnt Sienna. Using dry-brush technique, drag a ½-inch (12mm) square brush across the rough paper surface to create a mottled effect, suggesting the rough surface on the road. Be careful not to cover too much of the road or you will lose the contrast of the trees reflected in the puddle.

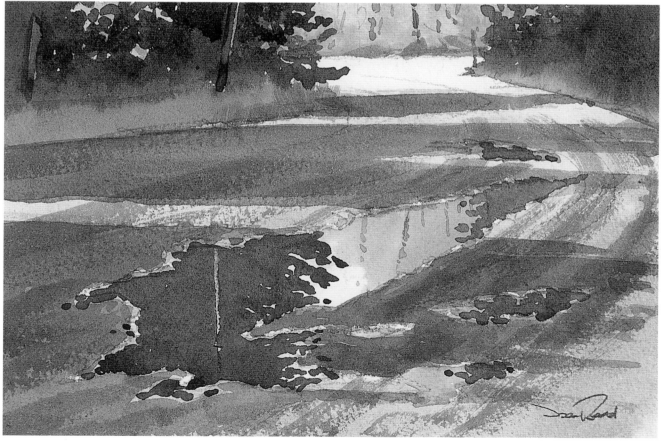

A Puddle on the Road With Fall Reflections
7½" × 11" (19cm × 28cm)
Watercolor on Fabriano 300-lb. (640gsm) rough watercolor paper

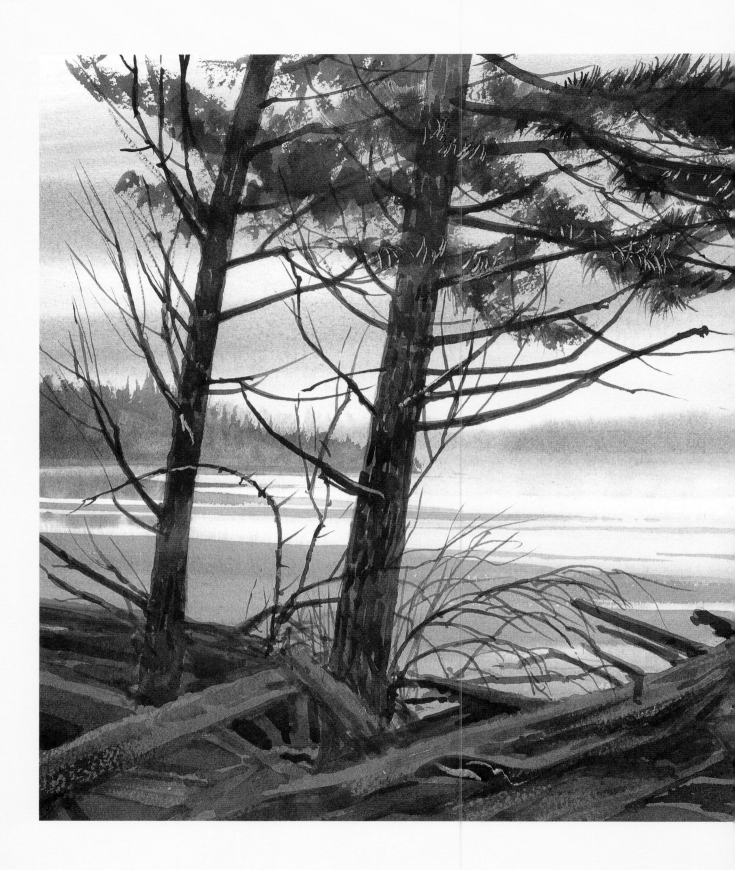

PAINTING WATER STEP BY STEP

As you work through the four larger demonstrations in this chapter, remember that you're not trying to get your works in the Louvre yet. It's okay if you strike out as you work through them. After all, even Babe Ruth struck out time after time. But any player who hits one out of three with regularity is regarded as a legend. The same holds true with painting. So why not paint as many pictures as you can with this attitude? Just keep swinging the bat!

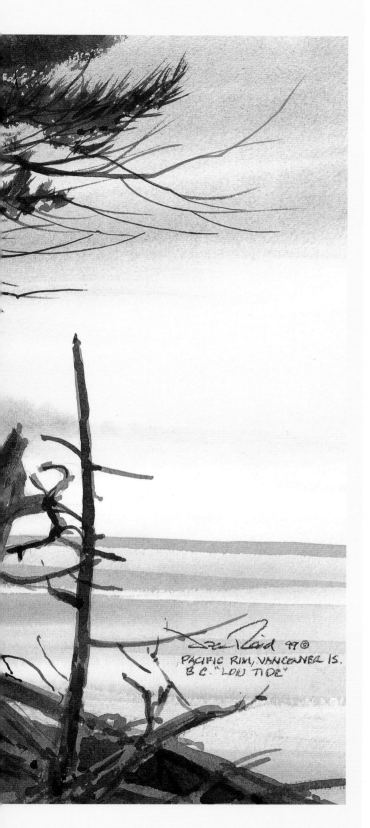

Low Tide
14" × 20" (36cm × 51cm)
Watercolor on Winsor & Newton 260-lb.
(550gsm) rough watercolor paper

Demonstration One: Rock Reflections on a Wet Sandy Beach

This painting is a Shibui (a Japanese term that's used to describe paintings that use only melancholy colors). Melancholy colors evoke feelings of peace and tranquility, which are typical of wet, misty ocean scenes. If you paint scenes like this on site, be watchful as reflections on wet sand change fast, often disappearing as quickly as they appear.

Palette
Burnt Sienna
Cobalt Blue
Raw Sienna
Ultramarine Blue
Viridian Green

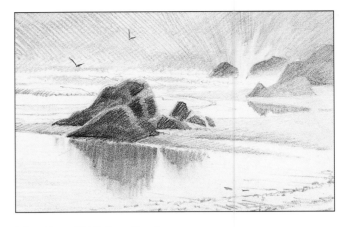

The Pencil Value Study

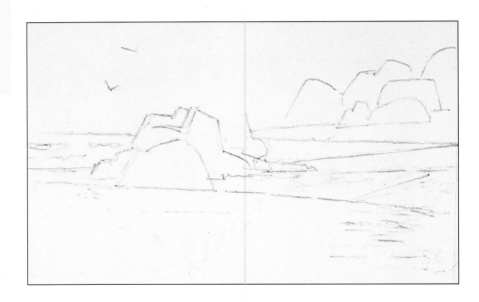

Step 1
Make a light pencil drawing to indicate the major forms and shapes.

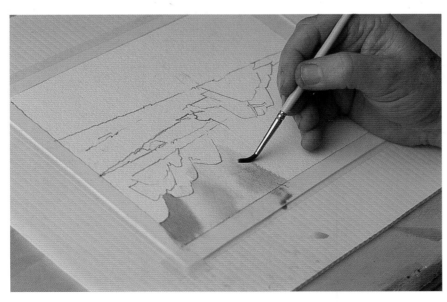

Step 2
Mix a light-value wash of Cobalt Blue. Turn the painting upside down and wash the sky area with clean water and paint wet-in-wet.

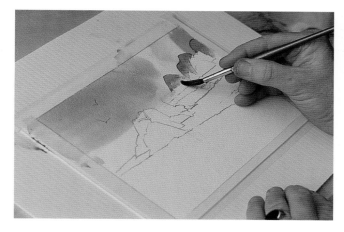

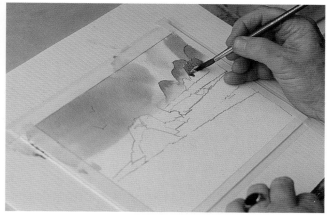

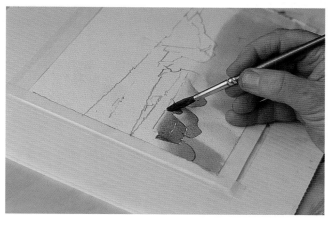

Step 3

As shown in these three photos, deepen the wash with Burnt Sienna to a soft blue-gray. Paint the distant rocks, using a graded wash on the bottom to suggest a haze. Deepen the wash with a touch of Viridian Green and paint the next closest single rock, using a graded wash toward the bottom.

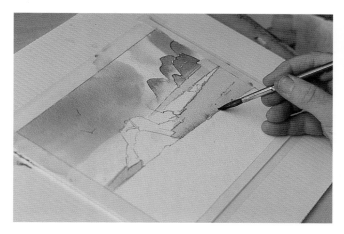

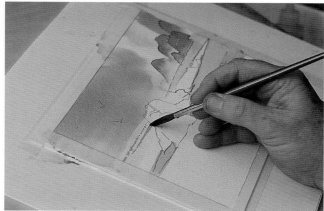

Step 4

Mix a raw umber wash from Cobalt Blue, Raw Sienna and Burnt Sienna. Paint the sand beach in the foreground, painting carefully around the rocks. Use a lightened value of the raw umber mix for the distant beach.

Step 5

Mix a wash of Cobalt Blue. Suggest distant breakers by painting the background ocean and leaving strips of white to suggest whitecaps. For the waves near the rocks, add a touch of Viridian Green to the wash.

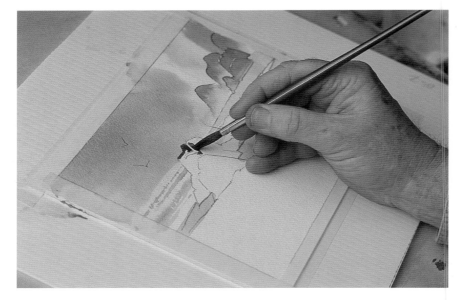

Step 6

Mix a dark wash from Ultramarine Blue and Burnt Sienna and paint a graded wash that begins with an emphasis on Burnt Sienna and completes with a blue-gray. Paint around the seagull, leaving the paper white. At the base of the main rock, drop a touch of Viridian Green to enhance the color.

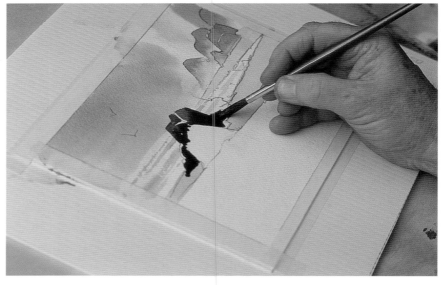

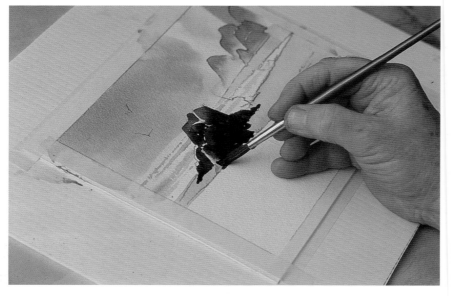

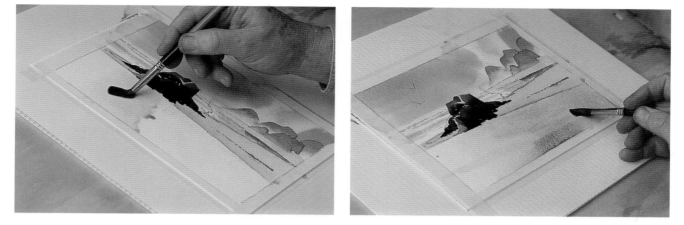

Step 7

Mix a light gray wash of Cobalt Blue and Burnt Sienna. Tip picture on its side. Paint a graded wash across the foreground, darkening the value as you near the right side. Gravity will cause the pigments to run.

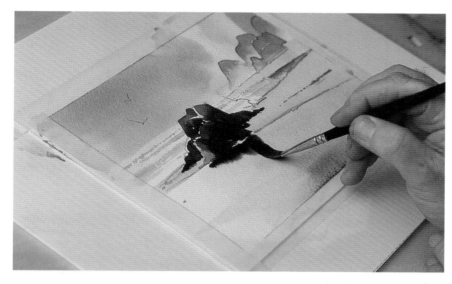

Step 8

With the same mix used to paint the rocks and a ½-inch (12mm) square brush, paint deft vertical strokes for the rock reflections in the wet sand.

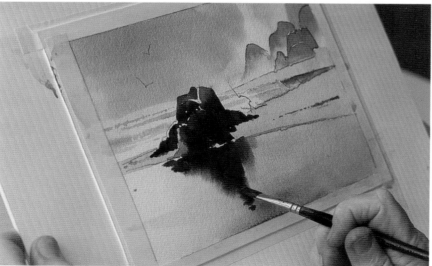

Step 9

Wipe a ½-inch (12mm) square brush dry and render a couple of horizontal strokes across the reflections.

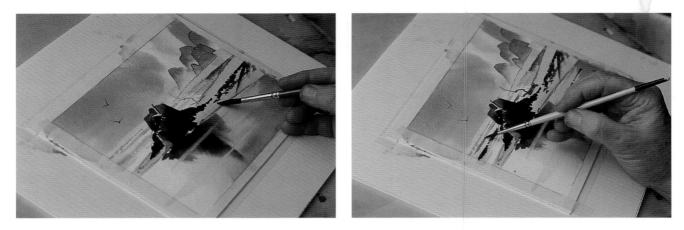

Step 10

Using Ultramarine Blue and Burnt Sienna, mix a dark brown wash and drybrush across the sand to indicate flotsam from the sea on the beach. Then using a no. 8 round brush, paint a dead tree on the right side of the rocks and also add some depth to the breakers.

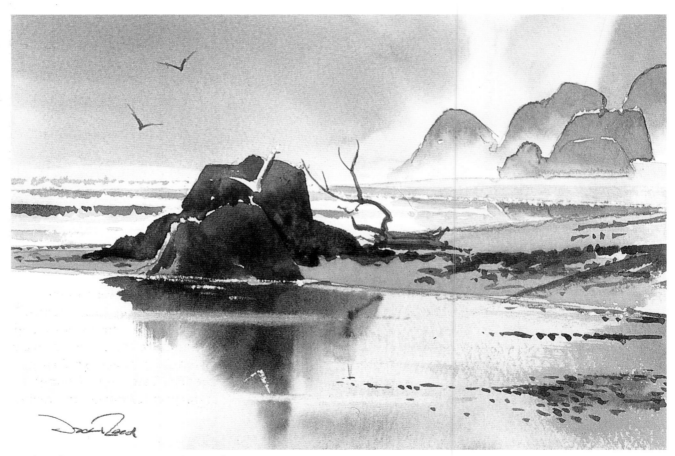

Rock Reflections on a Wet Sandy Beach
7½" × 11" (19cm × 28cm)
Watercolor on Arches 300-lb. (640gsm)
rough watercolor paper

Demonstration Two: Rain and Mist on West Coast

When subjects are wet, they appear dull, especially in hazy light. The best way to achieve this is to use the earth colors.

Palette
Burnt Sienna
Cobalt Blue
Raw Sienna

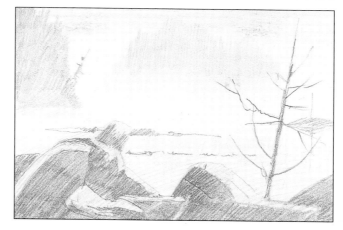

The Pencil Value Study

Step 1
Make a light pencil drawing to indicate the major forms and shapes.

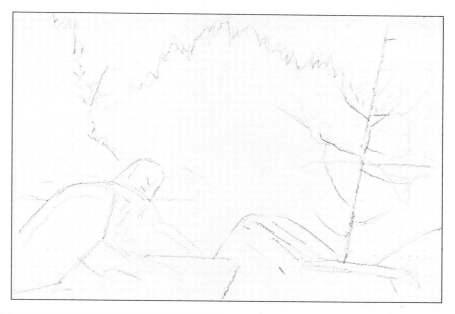

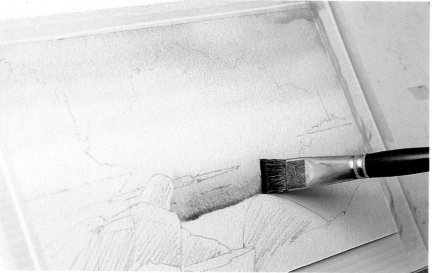

Step 2
Mix a soft gray wash from Cobalt Blue and Burnt Sienna. Turn the paper upside down and, beginning in the center, lay clear water. Add the gray gradually. Let dry. Turn painting upright and repeat for foreground rocks.

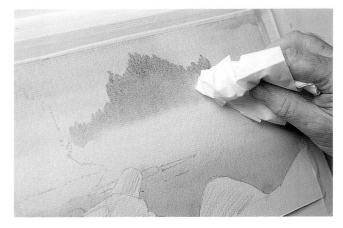

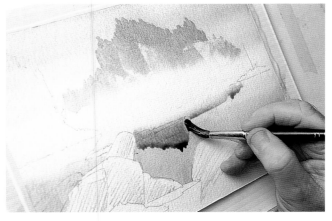

Step 3
With the same mix, paint the mist-covered island in the middle, adding water gradually toward the bottom. With a tissue, lift portions at the bottom to enhance the illusion of drifting mist.

Step 4
Deepen the mix and paint the island reflection.

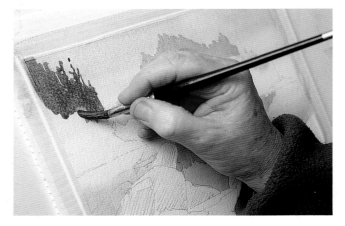

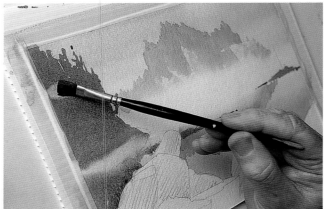

Step 5
Mix a brown wash from Cobalt Blue and Burnt Sienna. Using a no. 12 round brush, paint the rocks and trees on the far left, including the reflections.

Step 6
Wet a ½-inch (12mm) square brush with clear water and then squeeze dry. Lift out patches of cloud.

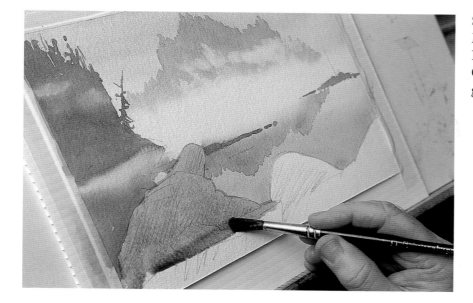

Step 7

Mix a raw umber wash from Raw Sienna, Burnt Sienna and Cobalt Blue. Paint the foreground rocks.

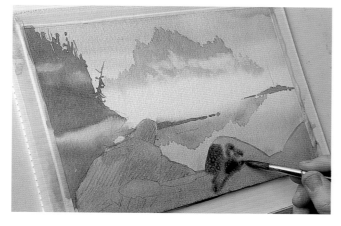

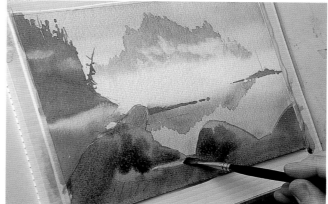

Step 8

As shown in these three photos, while still wet, drop a dark brown wash of Cobalt Blue and Burnt Sienna on the rocks. Squeeze dry a ½-inch (12mm) square brush and lift out pigment to create highlights.

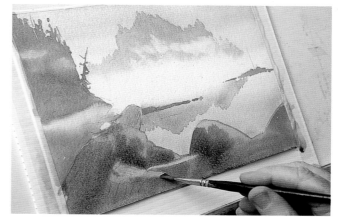

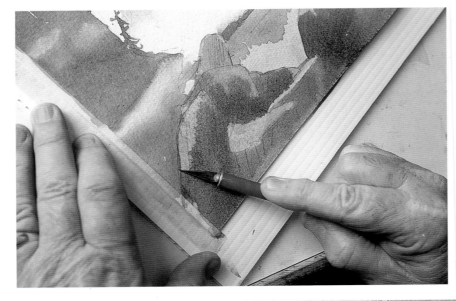

Step 9
Scrape the moist paper with a utility knife on its side to create a textured highlight.

Step 10
Increase the value of the rock shadows with a dark brown wash of Cobalt Blue and Burnt Sienna.

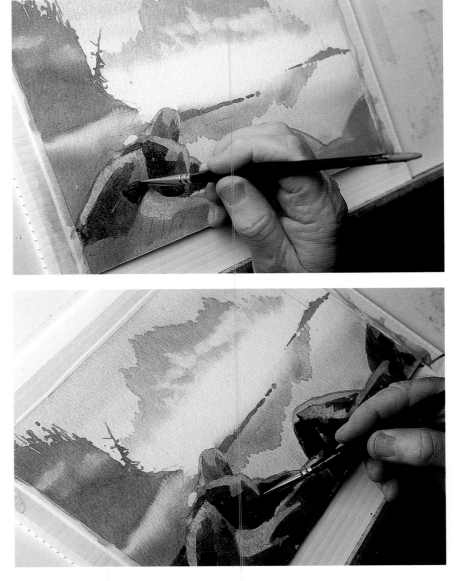

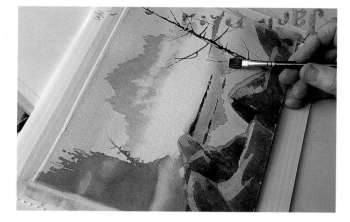

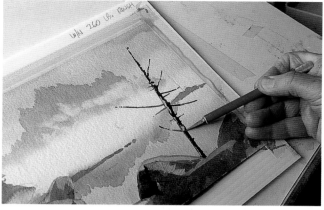

Step 11
Render the floating seaweed on the water surface in the background. Using Cobalt Blue and Burnt Sienna, paint the dead tree in the foreground.

Step 12
Use a knife to score texture on the bark.

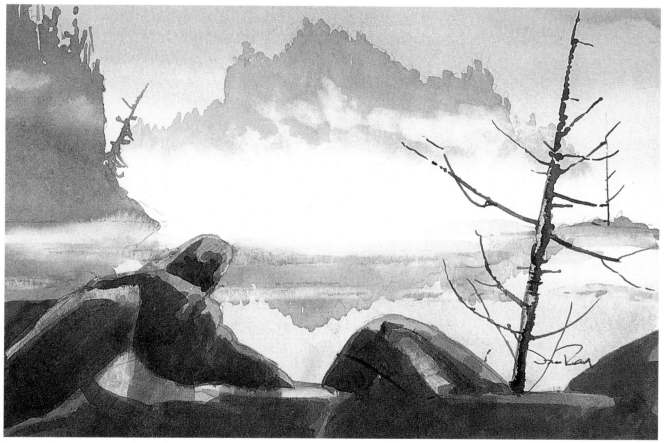

Rain and Mist on West Coast
7½" × 11" (19cm × 28cm)
Watercolor on Winsor & Newton 260-lb. (550gsm)
rough watercolor paper

Demonstration Three: Submerged Driftwood and Tree Reflections

What fascinated me most about this study of an old stump found at Macdonald Lake in Glacier National Park was that I could see it under the water. The key to painting this study's submerged subjects is to incorporate graded washes. When you paint with graded washes, part of the subject disappears.

The Pencil Value Study

Palette
Burnt Sienna
Cobalt Blue
Ultramarine Blue
Viridian Green

Step 1
Make a light pencil drawing to indicate the major forms and shapes.

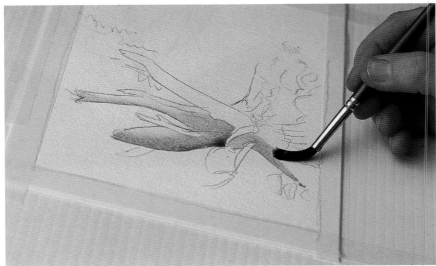

Step 2
Mix a light brown wash of Cobalt Blue and Burnt Sienna. Using a no. 8 round brush, start a series of graded washes, beginning with the driftwood. As you paint, leave small highlights for branches. Complete the main trunk of the stump, which is submerged in the water, using a graded wash.

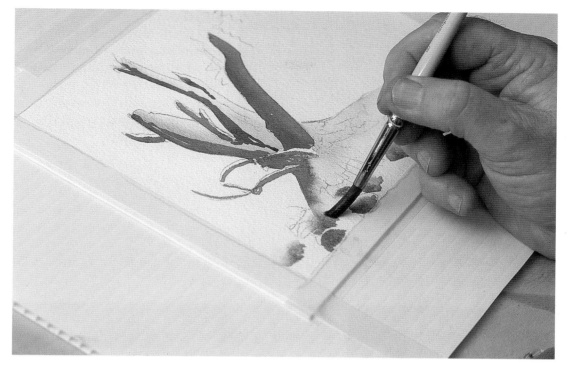

Step 3

Deepen the value of the wash and paint the shadow areas, as well as some of the rocks. The rocks at the base of the trunk are really a series of little graded washes.

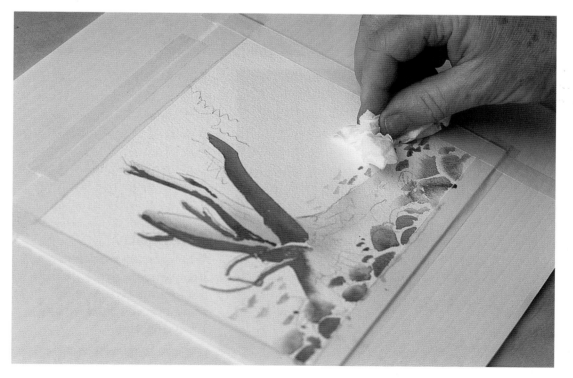

Step 4

With a tissue, lift color from the rocks.

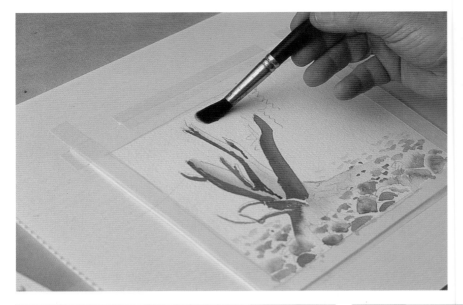

Step 5

Mix a soft blue wash of mostly Cobalt Blue with a touch of Burnt Sienna. Begin with clean water at the top of the water area, adding the blue wash gradually, and painting deftly around the stump.

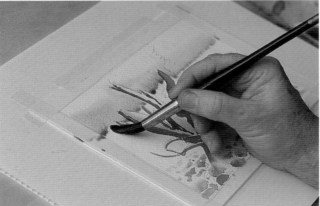

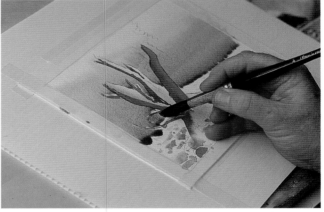

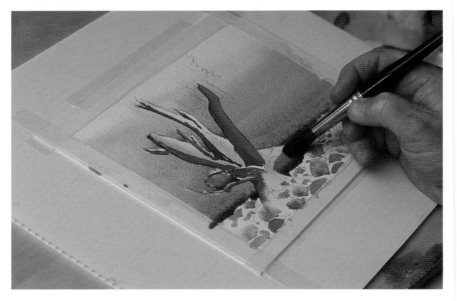

Work Quickly

When glazing with nonstaining pigments, work quickly so the underlying colors don't become agitated and blend together.

Step 6

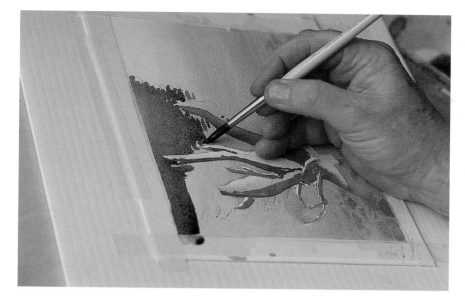

Mix a dull green wash with Viridian Green and Burnt Sienna. Using a flat wash, begin at the top of the paper and paint the tree reflections on the water.

Step 7

Mix a Cobalt Blue wash and define some of the waves in the midportion of the water area. If any strokes appear too dark, lift a bit of color with a tissue. Darken and thicken the wash toward the bottom of the paper. Let dry.

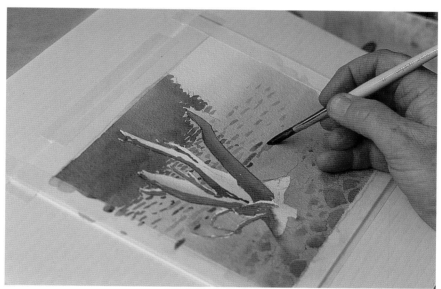

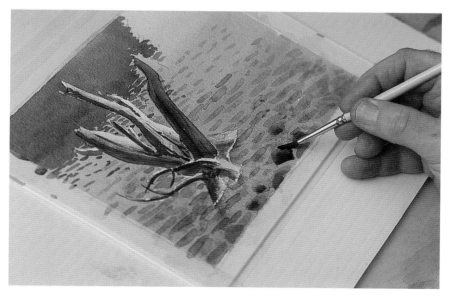

Step 8

Reinforce the rocks by glazing over them with the brown wash. Let dry.

Step 9
Mix a dark brown wash with Burnt Sienna and Ultramarine Blue. Using a no. 8 round brush, paint detail on the wood.

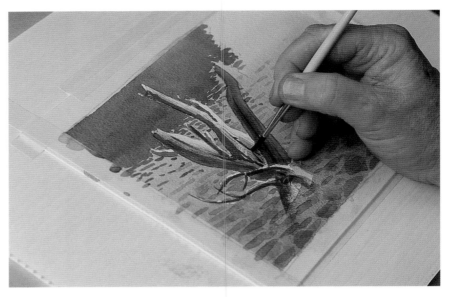

Step 10
Using the same mix, drybrush the wood to create a speckled effect. Let dry.

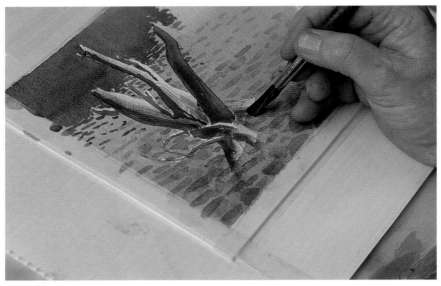

Step 11
Take a knife and create sparkle by scraping where the stump enters the water.

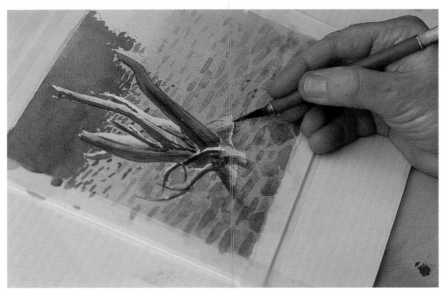

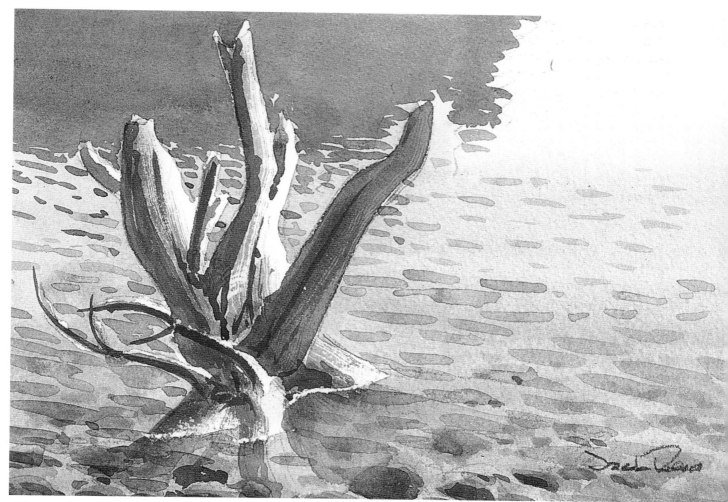

Submerged Driftwood and Tree Reflections
7½" × 11" (19cm × 28cm)
Watercolor on Fabriano 300-lb. (640gsm)
rough watercolor paper

Demonstration Four: Road Reflections on a Rainy Day

In this maritime scene taken near Lunenburg, Nova Scotia, I've painted breaking sun after a heavy rainstorm. I've suggested light breaking through the clouds by leaving pure white paper in the upper left corner. The graded gray clouds also suggest a storm that has just blown over.

Palette
Burnt Sienna
Cobalt Blue
Raw Sienna
Ultramarine Blue

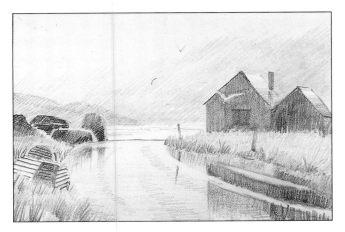

The Pencil Value Study

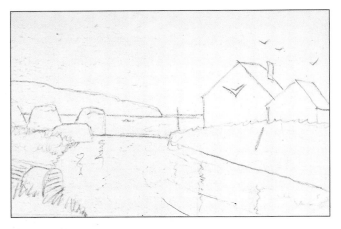

Step 1
Make a light pencil drawing to indicate the major forms and shapes.

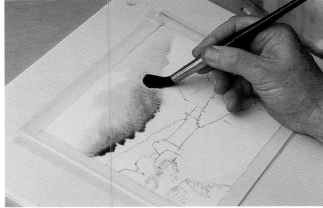

Step 2
Wash clear water over the upper left portion of the sky. Using wet-in-wet, tint the sky area with Raw Sienna to suggest clouds breaking. Complete the sky using wet-in-wet with a brown wash of Cobalt Blue and Burnt Sienna. Let dry.

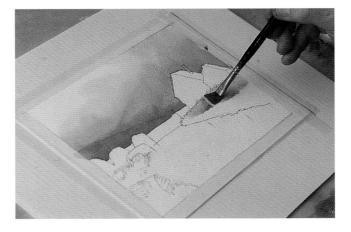

Step 3
Using Raw Sienna, render the grass on the right-hand side.

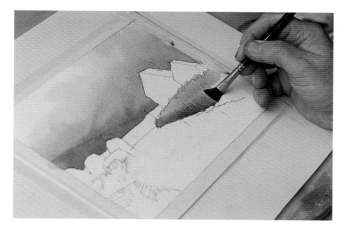

Step 4

Mix a deep-value brown wash from Burnt Sienna and Cobalt Blue. Paint shadows of the grass at the edge closest to the road.

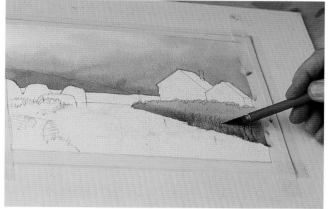

Step 5

While still wet, score with a knife to suggest the texture of the grass.

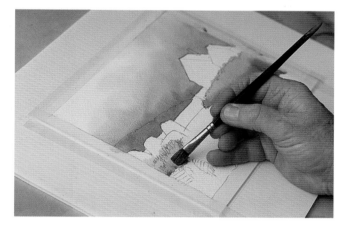

Step 6

Repeat steps three, four and five for the other side of the road.

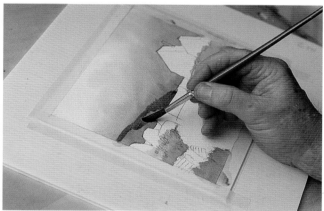

Step 7

Deepen the Burnt Sienna and Cobalt Blue wash and paint the distant headland.

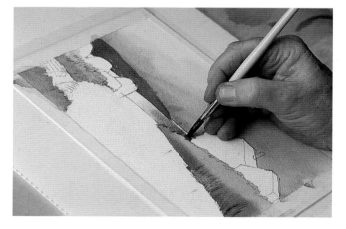

Step 8

Mix a wash of Cobalt Blue for the sea. Start with clean water and paint a graded wash, leaving a slice of light between the sky and the edge of the distant water.

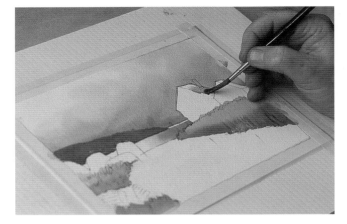

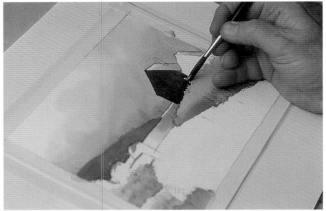

Step 9

Mix a wash from Burnt Sienna. Paint light washes on the building roofs.

Step 10

Mix a dark brown wash from Burnt Sienna and Ultramarine Blue. Using a no. 12 show card lettering brush, paint the main building.

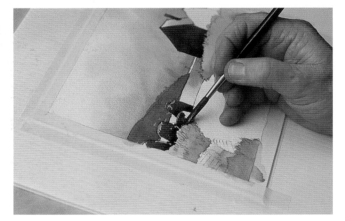

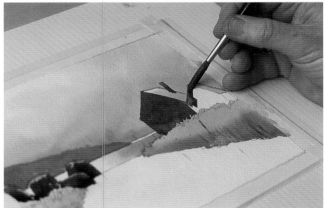

Step 11

Using a no. 12 show card lettering brush and a brown mix, paint the chimney. Paint the details of the rocks, leaving a bit of Burnt Sienna on the top edge of the rocks. Also paint the lobster pot with a graded wash, working from light to dark.

Step 12

Mix a light-value brown wash of Cobalt Blue and Burnt Sienna. Tint the shed on the extreme right.

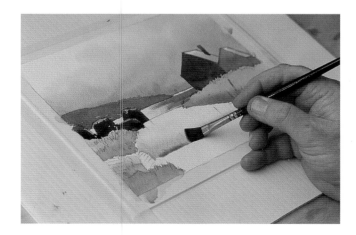

Step 13

Deepen the wash and paint a very wet graded wash for the road down to the sea.

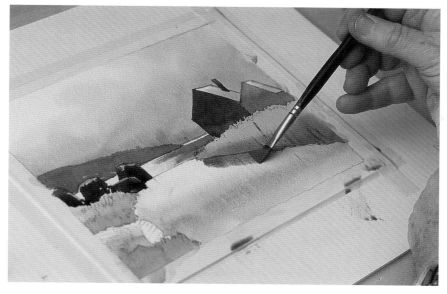

Step 14

With a ½-inch (12mm) square brush and wet-in-wet technique, drop in the grass and building reflections, using a darker value of the colors used for the grass and building. Note that the value of the reflection is somewhat lighter on a wet road. Repeat for the reflections of the rocks.

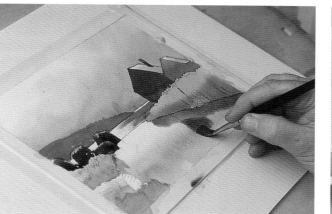

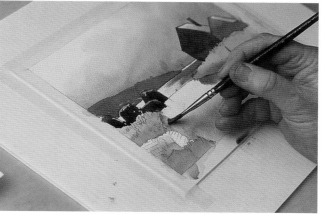

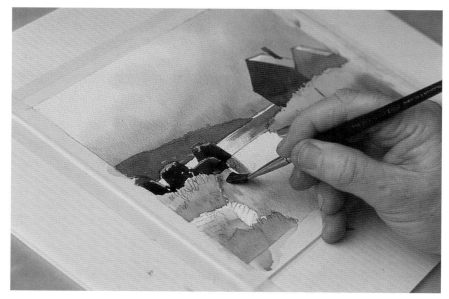

The Show Card Lettering Brush

The no. 12 show card lettering brush works well for square shapes of buildings. For thick strokes, press down, for thin ones, apply less pressure.

Step 15

Take the wet ½-inch (12mm) square brush and wipe out the paint with your fingers, pinching the ends. Now, with a very deft stroke, lift out a highlight of the building reflections. Work as quickly as you can. If the paint becomes too dry, let it dry completely and then glaze with clean water. When water has settled back in, agitate the area with a scrub brush and lift with a tissue.

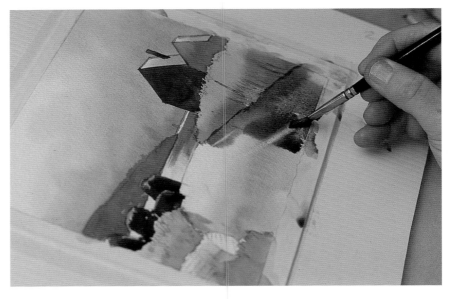

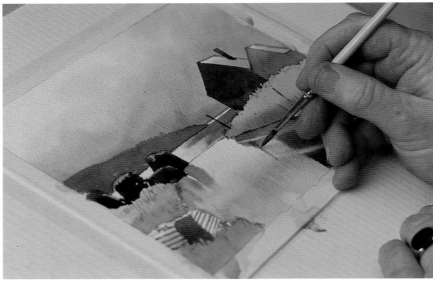

Step 16

Using the no. 8 round brush and a Raw Sienna, Burnt Sienna and Ultramarine Blue wash, paint reflections of the grass, the shadow area under the lobster pot, and the reflection of the chimney.

Step 17

Using a mix of Ultramarine Blue and Burnt Sienna, drybrush texture on the road. Let dry completely.

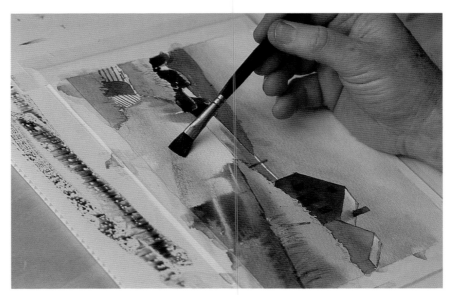

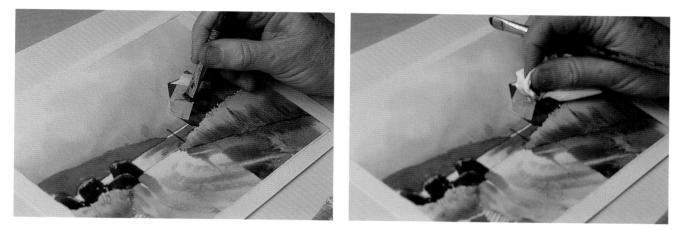

Step 18

On a piece of tape, draw and cut out the outline of a seagull. Place the tape on the painting, making sure it is completely dry first. Scrub clean water over the cutout impression and lift it out with a tissue. With the fine tip of the no. 3 rigger, drop in a couple more seagulls.

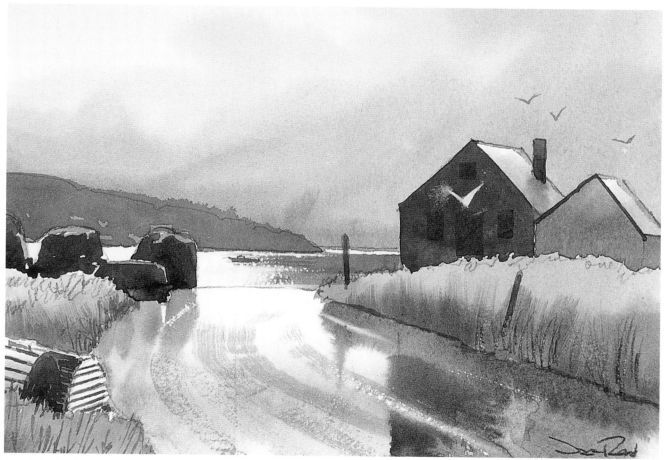

Road Reflections on a Rainy Day
7½" × 11" (19cm × 28cm)
Watercolor on Arches 300-lb. (640gsm) rough watercolor paper

Gallery

In this painting, I wanted to achieve the feeling of sunlight reflecting off the water and coming down through the woods. You'll notice a bit of the Rose Madder Genuine didn't mix thoroughly in the wash and so I left it. It added a nice touch.

Sun Break Reflections
14" × 20" (36cm × 51cm)
Watercolor on Winsor & Newton 260-lb. (550gsm) rough water-color paper

I've always been fond of the way drifting snow diffuses distant objects. So in this case there were two things I wanted to do: First, I love the way teasels catch the snow and I wanted to show those, so I used a bit of masking to mask out some of them and lifted out the rest. Second, I couldn't decide whether to put a building in the painting, so as an afterthought I painted just a rough sketch.

Rail Fence and House in Snow
14" × 20" (36cm × 51cm)
Watercolor on Arches 300-lb. (640gsm) rough watercolor paper
Collection of Mr. Cam Richardson

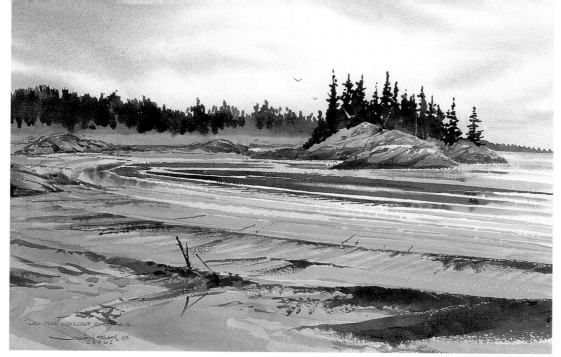

Low Tide on Crescent Beach
14" × 20" (36cm × 51cm)
Watercolor on Saunders Waterford 200-lb. (425gsm)
cold-pressed watercolor paper

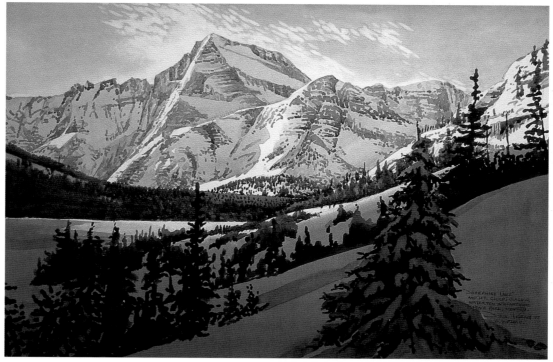

In summer 1997 I was the first of a series of guest artists invited to the park, and to thank the U.S. National Park Service, I painted this scene in the winter.

Josephine Lake, Glacier Waterton International Peace Park
14" × 20" (36cm × 51cm)
Watercolor on Arches 300-lb. (640gsm)
rough watercolor paper
Collection of the National Park Service,
Glacier National Park

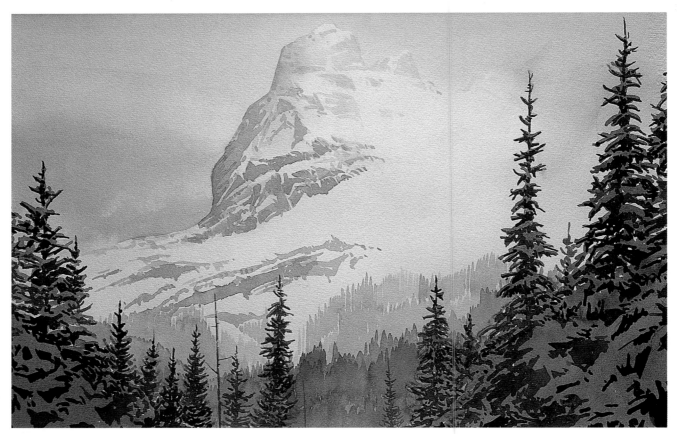

Glacier Waterton International Peace Park in Winter
14" × 20" (36cm × 51cm)
Watercolor on Arches 300-lb. (640gsm)
 rough watercolor paper

Just after it snows, while the sky is still overcast gray, the snow appears a warm pink color. Here I've achieved this transition period in addition to the diffused look that suggests it's snowing.

Winter Haze
20" × 28" (51cm × 71cm)
Watercolor on Fabriano 300-lb. (640gsm) rough watercolor paper

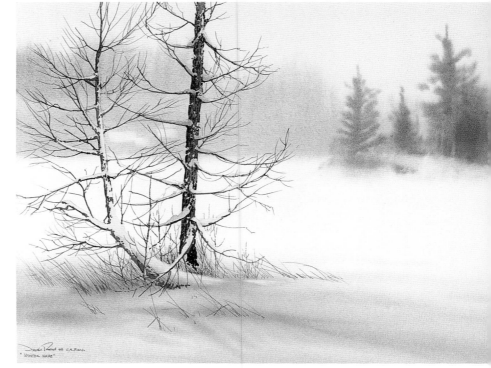

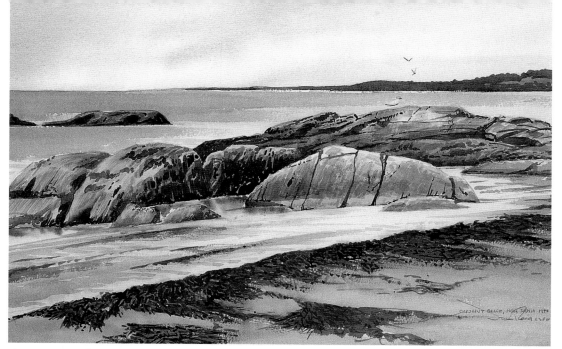

Crescent Beach, Nova Scotia
14" × 20" (36cm × 51cm)
Watercolor on Arches 300-lb. (640gsm)
rough watercolor paper

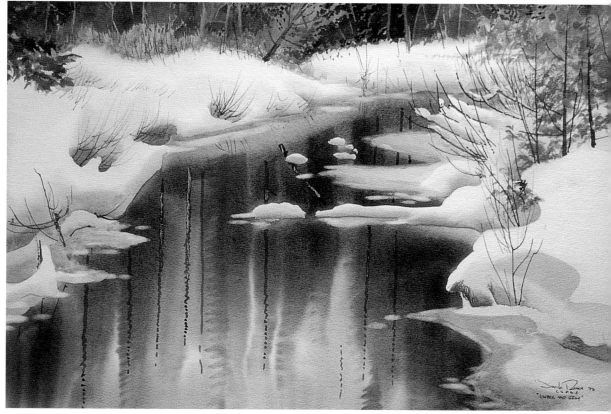

Reflections are often not what they should be. Here I've just tried to achieve the feeling of reflections, so I've intentionally painted hard edges along the edge of the water and the tree line. To do this I used strong wet-in-wet technique for the reflections—it's something that has to be done very directly and then left.

Umber and Gray
20" × 28" (51cm × 71cm)
Watercolor on Arches 300-lb. (640gsm)
rough watercolor paper

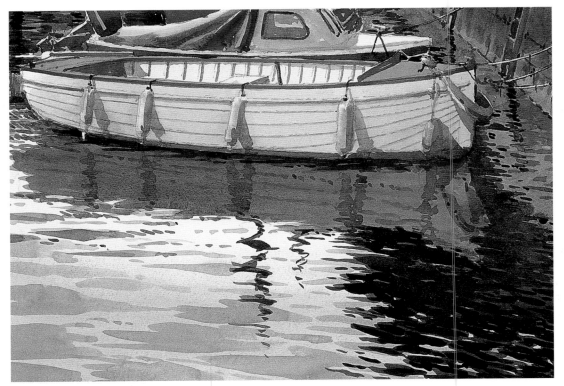

This on-site watercolor was painted at Dartmouth Harbour, England, during a watercolor workshop some years ago.

Boat at Rest
11" × 15" (28cm × 38cm)
Watercolor on Saunders Waterford
200-lb. (425gsm) cold-pressed water-
color paper

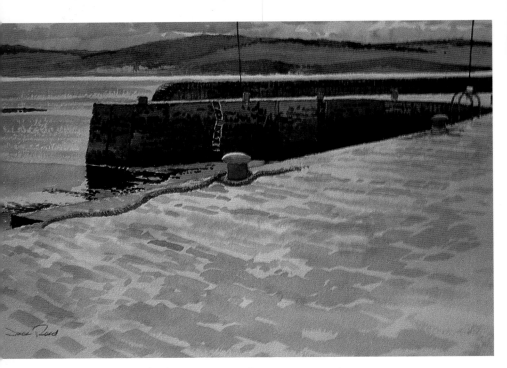

It's always tricky to paint when the tide is rising or falling—you have to set in your mind just where the tide line will be in the finished work. I was intrigued with the contrast between the strong zig-zag of shadows and the strong light and result-ing colors on the rocks.

Near Lahinch, Clare, Eire
14" × 20" (36cm × 51cm)
Watercolor on Saunders Waterford
200-lb. (425gsm) cold-pressed water-
color paper
Collection of Matt Stoddard

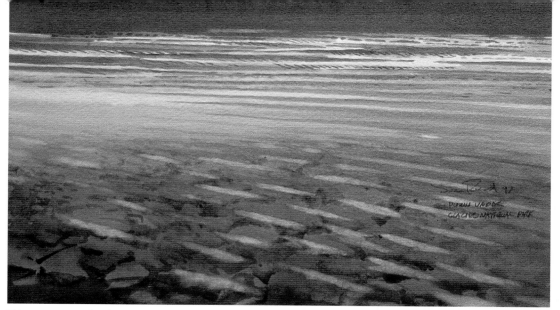

This was a completely unintentional painting. I began with the trees and mountains in the background and, as I got lost in the painting, I thought it would be great to paint the rocks under the water. But the picture was somehow flat, so I scrubbed out some elliptical shapes on the foreground water which gave the extra punch needed.

Down Under
14" × 20" (36cm × 51cm)
Watercolor on Saunders Waterford 200-lb. (425gsm) cold-pressed water-color paper

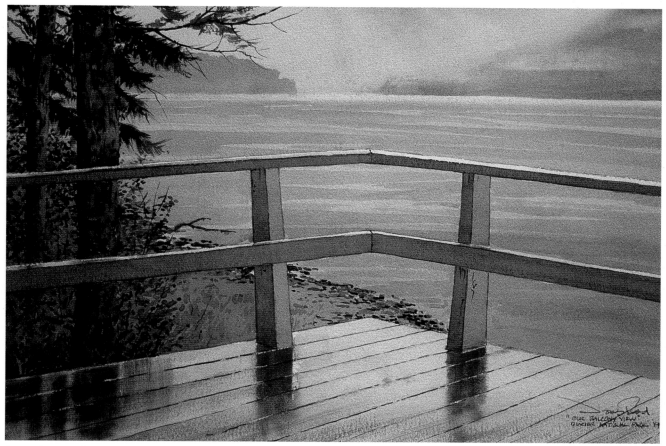

Capturing mood in a painting is more important to me than anything else. Here I've captured the wetness after a big storm.

Glacier Waterton National Park
14" × 20" (36cm × 51cm)
Watercolor on Saunders Waterford 200-lb. (425gsm) cold-pressed watercolor paper

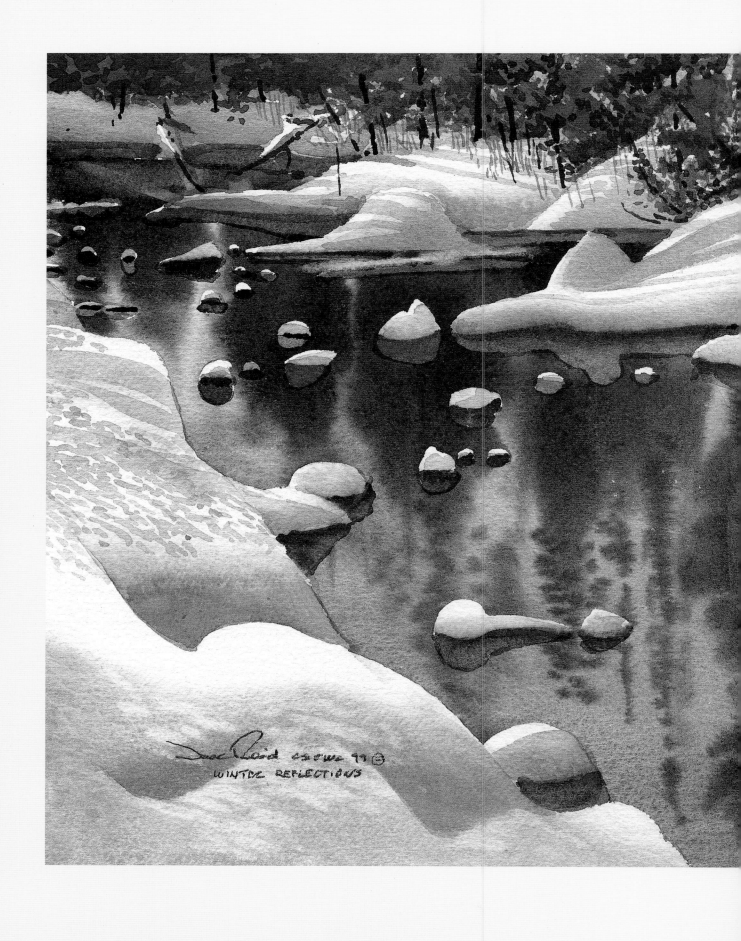

CONCLUSION

To achieve a great painting, I must paint the subjects and conditions I feel deepest about. For the demonstrations in this book, I've used subjects that I feel strongly about, and I hope you get as excited about them as I have.

If you too paint subjects that stir up strong emotions, I know you will remain inspired and stick with watercolor painting. Make no mistake—watercolor painting is difficult. But I know from personal experience if you keep things simple and practice, you're certain to improve. In my opinion, winning is not everything. It's how well you play the game. It's how well you really try to express your visual experience using this challenging medium. And it's how well you apply a comfortable, gentle discipline where you don't judge yourself or the results too harshly.

Preparing this book has been a challenge, as well as an enjoyment, and I hope sincerely that you've enjoyed these lessons and will feel a great sense of achievement that will come from practice. In the meantime, I wish you good health and prosperity.

Your fellow artist,

Jack Reid, elected Life Member,
Canadian Society of Painters in
Water Colour (CSPWC).

Winter Reflections
11" × 15" (28cm × 38cm)
Watercolor on Arches 300-lb. (640gsm)
rough watercolor paper

INDEX

Get ArtSmart with these great books from North Light!
The Guidance You Need to Become a Better Artist.